Benvenuto Cellini's fame and acclaim is largely related to the great bronze sculpture in Piazza della Signoria in Florence.

In fact the *Perseus* met with "extraordinary praise", as contemporary sources relate. It was a product of the sculptor's artistic maturity and was deliberately intended to be his masterpiece. Impetuous, quarrelsome and proud, Cellini was not particularly liked by his fellows, not even by those who most appreciated him as an artist and commissioned him to execute works of greater or lesser importance. In his autobiography he continually infers that he was treated with hostility even at the Medici court of Cosimo, the first Grand Duke of Tuscany, son of the great condottiere Giovanni dalle Bande Nere and relation of Duke Alessandro whom he had served so faithfully.

Yet despite the quarrels over money and the seesaw of relationships that these provoked, Cellini's patrons continued to support him, maintaining their faith in him even when the artist wished to embark on tasks that initially seemed beyond his abilities.

The fact is that the story of Benvenuto Cellini is emblematic of a situation that was common to many of the artists working in the Cinquecento. Until the previous century the Florentine painting, sculpture and goldsmithery workshops had turned out artists who could work in various materials and also draw up designs on paper: Brunelleschi, Ghiberti, Donatello, Michelozzo and Leonardo himself had shown great versatility without feeling constrained by their early workshop experience, which for some of them had involved drawing and then goldsmithery before proceeding to clay and wood. Rather than change their actual approach, they had simply altered the scale of what they were creating.

In practical terms, it was customary for the young workshop apprentices to learn first of all how to put their thoughts down on paper. Such graphic ability was then further developed by engraving precious metals with a burin and shaping small items in preparation for more important and complex commissions. Even architecture was learnt at the goldsmith's workbench; only later did the student move on to classical treatises such as that of Vitruvius or modern dissertations like the one drawn up by Leon Battista Alberti. It is thus hardly surprising that Cellini's *cursus honorum*, that is his creative activity, should have begun with smallish works that followed in the wake of generations of artists who started out as goldsmiths.

Benvenuto was born on All Saints Day in the year 1500, an apparently 'fatal' date, as he liked to underline in his autobiography. That his family was artistic

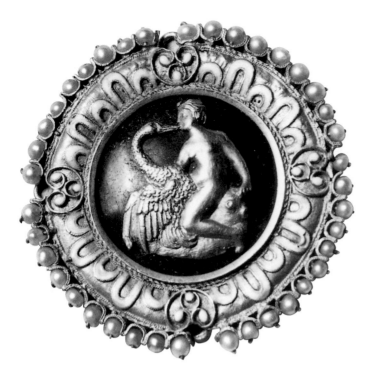

2. Benvenuto Cellini (?)
Hat medallion with Leda and the Swan
diam. cm. 3.8
Ferrara, Pinacoteca Nazionale

is clear from his account of his father's skill in carving a wheel-shaped mirror that rotated on a pivot so that the figures of the Virtues decorating it always remained upright: ROTA SUM: SEMPER QUO QUO ME VERTO / STAT VIRTUS is the motto he fittingly inscribed on it.

There is undoubtedly something a little self-opinionated about this recollection, as though it were of Cellini's own doing, an epithet of his life and adventures.

In fact Cellini's *Autobiography* reads a bit like a cloak and dagger novel, a sort of *Three Musketeers* in the sixteenth century idiom in which the figure of the artist is exalted in an unending sequence of astonishing events that are not so much documentary as human.

Despite the bygone style and age, today's reader will enjoy the fluency of Cellini's prose and will be drawn into the quick of the vicissitudes, fair and foul, that he relates in his account of the human and creative virtues that purportedly characterized his existence. Yet between the rapier thrusts and the harquebus shots, the shouts and the psalm-singing, the goldsmith and sculptor's true identity also gradually emerges from his detailed recollection of works that he actually created or merely designed.

He was a precursor of the *artiste maudit*, just as Caravaggio was to be a few generations later: men who would fight to defend their sense of honor and their dignity, both of which tended to be inflated to the point of becoming presumption and arrogance.

In some respects Cellini resembled Michelangelo, whose pride forbade him to bow before popes and sovereigns, not only as a statement of his own human worth, but also as a vindication of his art: that ability to express his thoughts in tangible and lasting forms when other mortals are limited to mere words.

Cellini served a brief apprenticeship with the goldsmith Michelangelo di Viviano da Gaiole, who crafted fine household objects in metal for the Medici residences, wares that were certainly splendid enough, though they rarely belonged to the realms of art as such. Cellini's father must have believed that his son's future was assured, whereas in fact the prospect was too narrow for an ambitious young man whose desire to operate on a grand scale had been fired by Michelangelo's *David* in front of the Palazzo della Signoria and was to withstand every sort of vicissitude. This explains why Cellini devotes few words to his master, the father of Baccio Bandinelli, the sculptor who was to become his rival. A long string of goldsmiths also appear in Cellini's *Life*, most of them unknown to us. Some were friends and dear companions, others hostile competitors or simply strangers left in a shade that they do not always deserve. Those in whose workshops he developed his manual skills included Antonio di Sandro, known as Marcone, in Florence; Francesco Castora in Siena; Graziandio the Jew in Bologna, Ulivieri della Chiostra in Pisa, and so on.

Before the age of twenty he was already studying the relief carvings on the ancient sarcophagi in Pisa, trying to absorb an approach that did not derive from Ghiberti, whose influence still held sway. Here he also began to develop his feeling for spacing out the figures in a complex frieze scene that was to prove useful in his work as a goldsmith engraving seals and coins.

Shortly afterward Cellini made a silver belt buckle in low relief that he happily relates as being his first autonomous work. It was "about the size of a little child's hand ... with a number of cherubs and some very beautiful masks" (p. 32). Although his description of it is brief, between the lines it nevertheless reveals the young artist's ambition: to compete with large scale statuary by translating into miniature terms the monumental forms that his famous contemporaries had created in marble and bronze.

This is what following in the 'manner' meant in the first half of his life, until he came to realize that he had the skill to translate his creations from the small to the large scale. It was a process of expressive expansion that coincided with the growth of his personal maturity under the caring patronage of François I of Valois: "I can truly say that what I am, and whatever good and fine things I have made, are all due to that marvelous King" (p. 274).

At the age of nineteen, Cellini headed for Rome, having turned down a proposal made by the sculptor Pietro Torrigiani, who was then working for the King of England and had suggested he should accompany him, possibly to work on a number of impor-

Mario

BENVENUT

SCALA/RIVERSIDE

© Copyright 1995 by SCALA, Istituto Fotografico
Editoriale, S.p.A., Antella (Florence)
Photographs: SCALA ARCHIVE
except no. 2 (Archivio Fotografico della Soprintendenza per i Beni
Artistici e Storici, Bologna); nos. 3, 4, 5 (British Museum, London); nos.
6, 7 (Museo Civico, Numismatico, Etnologico e Archeologico, Turin);
no. 21 (Musée des Beaux-Arts, Lyon); no. 25 (Fitzwilliam Museum,
Cambridge); nos. 26, 27, 29, 30-33, 35-37 (Kunsthistorisches
Museum, Vienna); no. 44 (National Gallery of Art, Washington); no. 54
(Ashmolean Museum, Oxford); no. 55 (© 1995 Sotheby's); no. 80
(Isabella Stewart Gardner Museum, Boston); nos. 81, 82 (Patrimonio
Nacional Archivo Fotografico, Spain); nos. 83-89 (Staatliche
Kunstsammlungen, Dresden); no. 92 (The Board of Trustees of the
Royal Armouries)
Editing: Marilena Vecchi
Layout: Ilaria Casalino
Translation: Kate Singleton
Printed in Italy by Amilcare Pizzi S.p.A.-arti grafiche
Cinisello Balsamo (Milan), 1995

Published by Riverside Book Company, Inc.
250 West 57th Street
New York, N.Y. 10107

ISBN 1-878351-50-8

1. Giorgio Vasari and collaborators
Cosimo I surrounded by artists, detail of the Portrait
of Benvenuto Cellini
Florence, Palazzo Vecchio

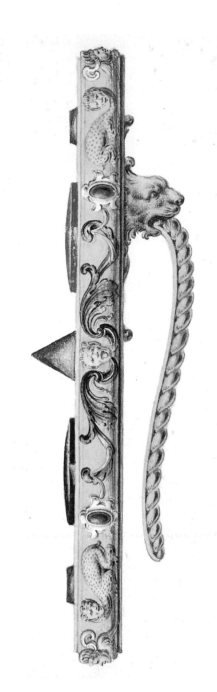

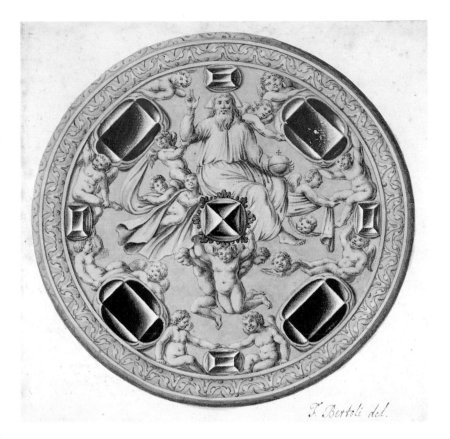

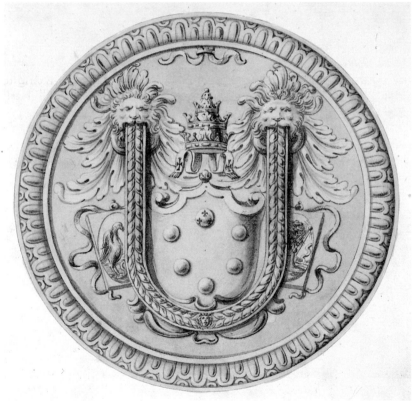

3. Francesco Bartoli
Profile of cope pin made by Cellini for
Clement VII
London, British Museum

4, 5. Francesco Bartoli
Front and back of the cope pin made by Cellini for Clement VII
London, British Museum

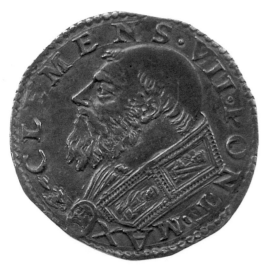

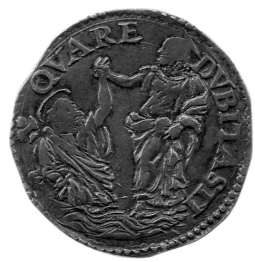

tant bronze funerary monuments that he had been commissioned to create.

Rome, the heart of Christendom, was considered a "den of vice" by many people, and not only the Reformation activists. However, it was also a melting-pot of artistic experience that was bound to be extremely stimulating for an ambitious young man of talent like Cellini who wanted to find out what he could do. It was here that he made his first salt-cellar: "… a little casket, designed after the porphyry sarcophagus that stands in front of the door of the Rotunda" (p. 34). Tableware shaped like a "sepulcher", as contemporary inventories were wont to record such items, was relatively common at the time, especially in Rome where the passion for antiquity and archeological excavations had become so widespread that it smacked more of fashion than it did of culture.

For a while Cellini divided his time and energies between Rome and his native Florence, where he was employed in the workshop of Giovambattista Sogliani at the Mercato Nuovo. During this period he made a bridal girdle or "heart-key", as it used to be called, in silver for Raffaello Lapaccini and some candlesticks and a water-bowl or "acquareccia" for the Bishop of Salamanca. Moreover he also set some diamonds belonging to Porzia Chigi in a jewel shaped like a lily, adorning it with little masks and cherubs and animals, all of them exquisitely enameled.

Cellini was clearly proud of these works, though it is not easy to imagine exactly how they must have looked, with their figurative ornaments in relief and the little masks of his own design that he used to embellish various objects, including the salt-cellar mentioned above. It may well be that the grotesque faces he was so fond of resembled those that were to decorate certain of the architectural parts of Michelangelo's Sagrestia Nuova at San Lorenzo, or indeed the ones designed by Tribolo for the floors of the Biblioteca Laurenziana in the same complex. It is also likely that Cellini's silver water-bowl was decorated with relief or free-standing ornaments as well, like those that feature in drawings by Giulio Romano at the British Museum in London. Certainly these early works were

nothing like as ornate as the ones he created during his maturity.

Despite the emphasis with which Cellini describes his first steps as an artist, the career itself evidently did not look particularly secure, to the extent that there was even a chance that he might become a musician at the Papal court instead. That at least is what his father had in mind for him. But the idea of a steady salary and a somewhat gray routine had no charm for a restless young man who had already received important commissions from Cardinals Cybo, Cornaro, Ridolfi and Salviati, among others.

In his *Autobiography* Cellini refers enthusiastically to the services he was able to render to the beautiful and charming Porzia Chigi. He was dazzled by a woman for the first time, and so great was his admiration for her that he did not even want to be paid. Unfortunately his social status was so far removed from that of the women he would have liked to frequent that in the end and after much suffering he separated his sexual life from his matrimonial aspirations. As a result he appeased his passions with his models, most of whom are described as loose and sly, rather than opt for the elevated feelings that an improbable 'courtly' love might have brought him.

By sacrificing his private life on the altar of art Cellini was actually aiming at the kind of social recognition that only such fame and glory could have assured. In so doing he perfectly fulfilled the role of the courtier artist described by Baldassarre Castiglione, who advised the restless gentlemen of his day to seek fortune in the only two ways that he judged to be honorable: through the sword or the pen; in this case with both. Indeed, in Cellini's account of his life the descriptions of goldsmithery alternate with those of terrible fights penned with great graphic verve.

This bellicose tendency comes into its own in the lively pages proudly devoted to the brief period he spent as an artilleryman on the glacis of Castel Sant' Angelo, where he was invested with the honorable role of defending the Father of Christianity besieged by the "barbarians" and offended by the Protestant soldiery. With Giuliano the Florentine he defended the

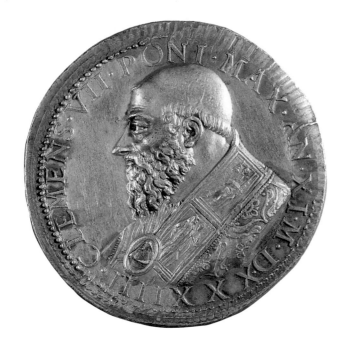

8. Benvenuto Cellini
Medal of Clement VII, obverse side
diam. cm. 4
Florence, Bargello Museum

9. Benvenuto Cellini
Medal of Clement VII, obverse side die
Florence, Bargello Museum

last bastion of Clement VII and later fired at the enemy trenches with a swivel-gun and a falconet, hitting the wretched Prince Philibert of Orange (1502-1530), who thus breathed his last in the Eternal City.

Between one anecdote and the next Cellini also mentions the odd work executed during this period in Rome: for the Gonfalonier of Rome, a "large gold medal to be worn on his hat, with a Leda and her swan engraved on it..." (p. 50); and a number of vases that resembled antique ones and passed from one Roman prelate to another in a sort of erudite game in which each owner tried to outdo the next in his knowledge of antiquities. These latter tales recall Vasari's account of Michelangelo's *Bacchus* and the *Sleeping Eros*, which were mistaken for products of antiquity even by experts. Such was the strength of the inspiration that the foremost artists of the time found in the Classical world.

On leaving the Pope's service, Cellini stayed for a while in Florence and then made for Mantua, where Federigo Gonzaga commissioned him to model a reliquary "for the blood of Christ, which the Mantuans say was brought to their city by Longinus" (p. 81). It was a figure of Christ sitting down with his left hand raised to hold the cross he was leaning against and the right hand making a gesture as if to open the wound in his side. Cellini also mentions other "little works" and the seal for Cardinal Ercole Gonzaga, as well as two gold hat medals, one for Girolamo Manetti of Siena and the other for a certain Federico Ginori. Whereas the first portrayed "Hercules wrenching open

the lion's mouth", the design of the second consisted of "a figure of Atlas cut on thin plate, with a crystal ball on his back to represent the sky. On the ball I had engraved the zodiac against a background of lapis-lazuli. It was all unbelievably beautiful, and it was completed with a little motto underneath which read: SUMMA TULISSE IUVAT" (p. 84).

Some experts believe that the designs of some of these small jewels were echoed in later works which have actually come down to us. However, since none of the originals exists today, the only one that we can conjure up in slightly more concrete terms is the cope button he designed for Pope Clement VII. At the British Museum in London there are three later drawings of a button that corresponds to the model described in the *Autobiography*: "While waiting for the money the Pope examined more carefully the excellent way I had fitted the diamond in with the figure of God the Father. What I had done was to place the diamond exactly in the center of the whole work, with the figure of God the Father, gracefully turning to one side, seated above it, and so the design was beautifully balanced, and the figure did not detract from the jewels. With his right hand raised, God the Father was giving a blessing; and beneath the jewel I had placed three cherubs, supporting the diamond with raised arms; the middle one was in full, and the other two in half relief. Round about I had designed a crowd of cherubs, beautifully arranged with the other gems. God the father was draped in a flowing mantle, from which the other cherubs peeped out; and there were many

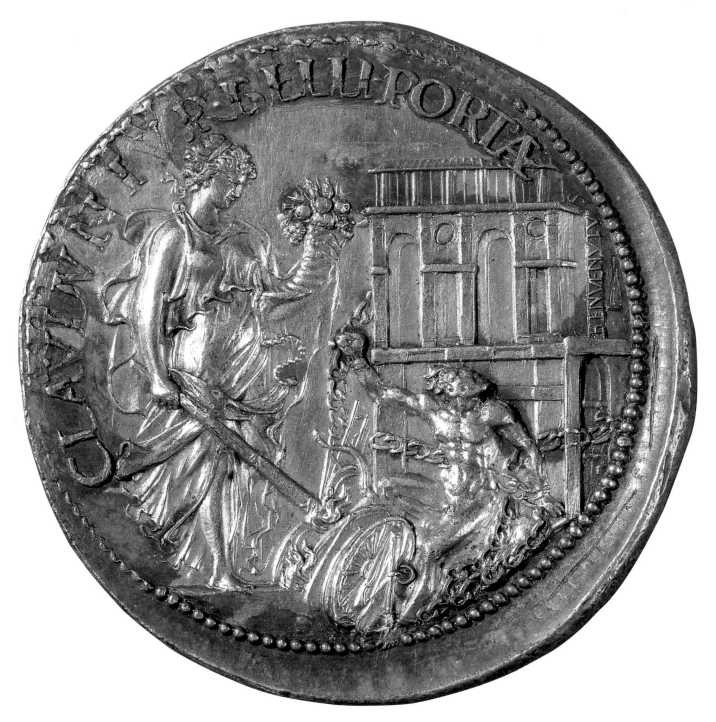

other exquisite adornments, all enhancing this beautiful work. It was made in white stucco on black stone" (p. 90).

What Cellini does not describe is the fine enamel work set into the button featuring sphinxes with bodies spotted like a leopard, masks and garlands. Nor does he mention the U-shaped fastening on the back consisting of a double plait issuing from leonine jaws; in the center the Medici coat of arms surmounted by the papal tiara and flanked by two rectangular plaques bearing the Pope's motto. The design won Clement's favor and support as well as the desired appointment as superintendent of the dies at the Papal Mint. This meant that Cellini had dies to design and could count on a secure income. Moreover there was also a commission for a golden chalice, which was never actually

10. Benvenuto Cellini
Medal of Clement VII showing the Allegory of Peace, first reverse side
Florence, Bargello Museum

11. Benvenuto Cellini
Medal of Clement VII showing Moses Striking Water from the Rock, second reverse side
Florence, Bargello Museum

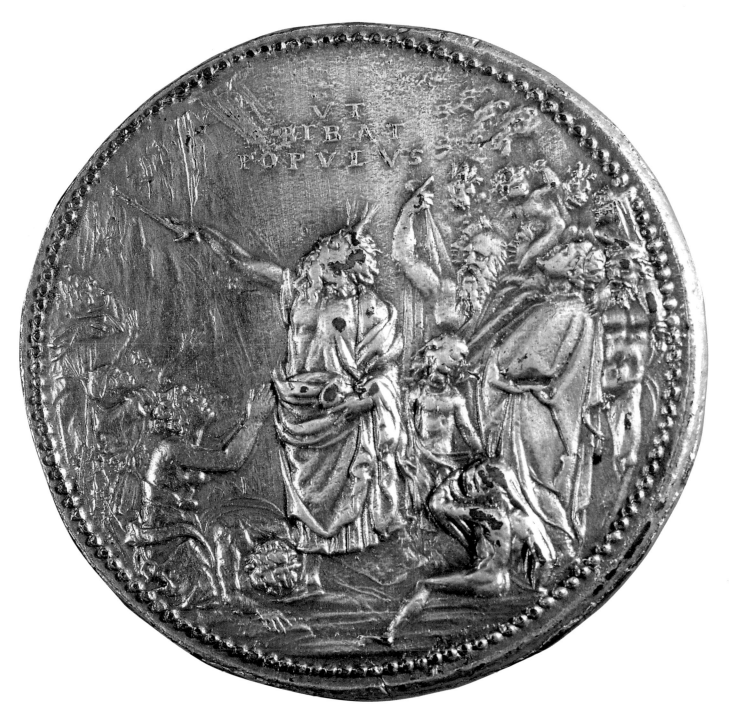

finished. In place of the node he modeled the figures of Faith, Hope and Charity, balancing them at the base with scenes in low relief showing the Nativity, the Resurrection and the Martyrdom of Saint Peter. It was a good period for Cellini, who also worked on a design for mounting what was then believed to be a unicorn's horn but was in fact a narwhal tooth, purchased by the Pope for seventeen thousand ducats and intended as a present for the King of France, François I of Valois. However, this design was not accepted, perhaps because it was too ingenious, or maybe only because it would have required a much greater quantity of gold than Tobia da Camerino's less imaginative creation.

In time Cellini's relationship with the Pope was undermined by slight disagreements which ultimately caused him to lose his various privileges. To regain the lost favor, he began to model a medal for Clement VII showing the Pope in profile on the one side, and on the other a scene of his own design with Peace burning a pile of weapons and the figure of Fury loaded with chains before a classical building; the Pope then commissioned an alternative reverse side with Moses striking the rock to quench the thirst of the Jews.

Paolo III Farnese was elected Pope when Clement VII died. He wished Cellini to continue his appointment at the Mint, but the artist's turbulent life led to his fleeing to Venice and then to Florence. Here he enjoyed the protection of Alessandro de' Medici, Duke of Florence. Though very much a tyrant and hated by the republicans, the Duke was also a generous patron of the arts; at least this is how he appears in Cellini's

12. Benvenuto Cellini
*Medal of Clement VII showing the Allegory of
Peace, die of the first reverse side
Florence, Bargello Museum*

13. Benvenuto Cellini
*Medal of Clement VII showing Moses Striking Water
from the Rock, die of the second reverse side
Florence, Bargello Museum*

account, which may well have been written with an
eye on the effect it would have on Cosimo I and
Francesco, his son, who were Cellini's patrons at the
time he was writing his *Life*.

Though the manuscript was only printed in 1728,
it was certainly ready by around 1560 and would have
circulated among the artistic and cultural circles of the
1560s, since Vasari mentions it in 1568. It is thus
easy to imagine that the author accepted the advice
of Benedetto Varchi and toned down certain narrative
asperities which might otherwise have irritated the
members of the Florentine dynasty. Moreover Cellini
dedicated plenty of space to his execution of the medal
with the image of Alessandro and the coins for the
Ducal Mint.

During this period Cellini spent more time in Rome
than in Florence. Although he had to face a series of
ups and downs, he also obtained a commission from
Pope Paul III to create a gold binding with figures,
enamel work and gems for an illuminated missal in-
tended as a gift for the wife of the Emperor Charles V.
On his way north he was also offered hospitality in
Padua by Pietro Bembo, whom he then accepted to
portray on a medal: "The first day I worked for two
hours at a stretch, reproducing his fine head so beau-
tifully that his lordship was astounded. He was a very
great man of letters and a poet of extraordinary gen-
ius, but since he was completely ignorant about my
own art he imagined that I had already finished,
whereas in fact I had hardly begun. I found it impossi-
ble to make him understand that to do it well required
a long time. In the end I decided to put into it all I
knew, and to give it all the time it needed: and since
he wore his beard short, in the Venetian fashion, it
proved very troublesome to make a head that I was
satisfied with... because he reckoned that after I had
made the wax model in two hours I ought to finish the
steel one in ten... He begged that I should at least do
a reverse for the medal, showing the horse, Pegasus,
with a wreath of myrtle round it. I did this in about
three hours and made a lovely job of it" (p.177).

Having promised Bembo that he would make a die
of the steel model, Cellini left for France, where he
met up with his countryman Rosso, who had been
working for the King for some time. Although Rosso
was a painter and therefore in no way in competition
with Cellini, he made no effort to help him become
part of the circle of court artists. So Cellini made his
way back to Italy and in 1537 made the acquaintance
of Ippolito d'Este, who was to play a major role in his
life for the next years, for good and for ill. He com-
missioned Cellini to make him a silver basin and jug
once he was back in Rome, where he also had to
"take in hand all the gold and jeweled ornaments for
the wife of Signor Gerolamo Orsino, father of Signor
Paulo, who today is the son-in-law of our Duke
Cosimo" (p.187). Cellini employed as many as eight
workmen, but the envy of his competitors was such
that they managed to get him discredited at the Papal

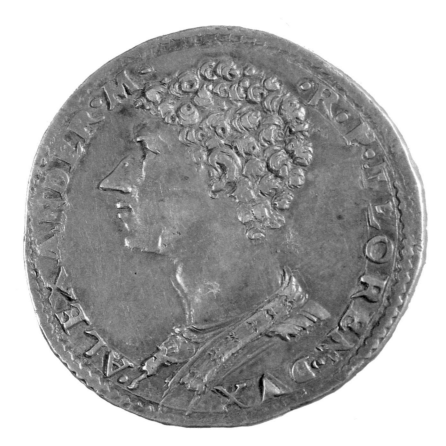

14. *Benvenuto Cellini*
40 soldo 'Testone' of Alessandro de' Medici; diam. cm. 2.9
Florence, Bargello Museum

15. *Giorgio Vasari*
Allegorical Portrait of Alessandro de' Medici
Florence, Uffizi Gallery

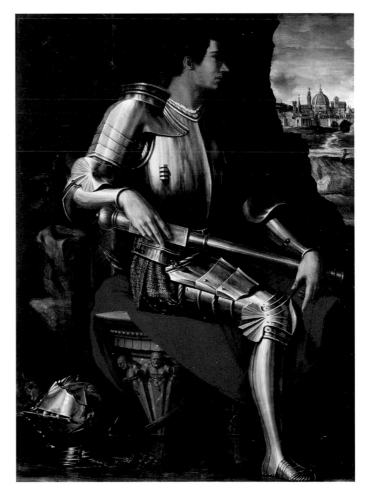

court and tried for stealing some of the precious stones that Pope Clement VII had had removed from their settings during the siege of Castel Sant'Angelo. Such accusations sullied his reputation and the current Pope actually had him thrown into prison in the very same fortress that he had helped defend. Cellini devotes many pages of his story to that terrible experience, telling of his relationship with the castellan, of the protection he was accorded by certain important persons of the time, and of the way different people interceded on his behalf. In the end he was so desperate that he tried to escape. And he succeeded, with the help of the Puccis, Cardinal Cornaro and Ippolito d'Este who had since become Cardinal Ferrara and who had done his best to get Monsignor di Montluc to convey François I of Valois's plea to the Pope for Cellini's release.

With the help of his assistant Paolo, once back at work Cellini focused on the commission for his protector Cardinal Ferrara. He made a fresh start on the jug, with "figures both in the round and in low relief, and the bowl was designed likewise, with figures in full relief and fishes in low relief" (pp.237-238). He was also commissioned to design the Cardinal's seal, of which there is a positive version in lead at the Musée des Beaux-Arts in Lyons: "This seal was as large as the hand of a twelve-year-old boy; I cut two scenes on it, in low relief, each of which told a story. One showed St John, preaching in the desert; the other, St

11

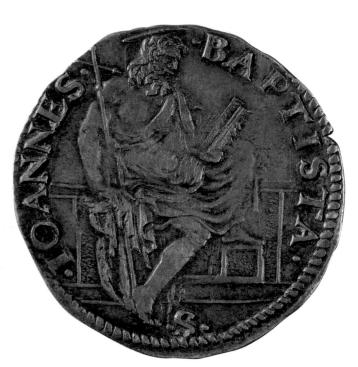

16. Benvenuto Cellini
40 soldo 'Testone' of Alessandro de' Medici showing Saints Cosma and Damian, reverse side
Florence, Bargello Museum

17. Benvenuto Cellini
'Giulio' of Alessandro de' Medici, obverse side diam. cm. 2.6
Florence, Bargello Museum

18. Benvenuto Cellini
'Giulio' of Alessandro de' Medici showing Saint John the Baptist, reverse side
Florence, Bargello Museum

Ambrose, on horseback and with a whip in his hand, driving the Aryans away. This showed such force and excellence of design and neat workmanship that everyone said that I had surpassed the great Lautizio, who specialized in this kind of work..." (p. 238).

We can get an idea of Cellini's style at the time from the lead die in Lyons. It is interesting to compare this with the cast that Lauzio di Meo made for Giulio de' Medici (Schneider Collection, Cleveland Ohio) or indeed with the original die that is kept at the Bargello Museum (inv. 7). Although this latter reveals some changes with respect to the Ohio die, the quality of the engraving rules out the possibility of its being a later copy or, as some have suggested, an "extra seal" (a self-defeating hypothesis, since the whole point of seals is that they should be unique and thus

able to authenticate a signature on an official document). Lauzio's seal would have been made before 1520, and is thus much earlier than Cellini's. Yet even bearing this in mind Cellini's work reveals the artist's extraordinary capacity for innovation. Whereas Luzio largely adheres to the principles of Raphaelesque composition, with the figures framing a traditional background consisting of architecture and a landscape, Cellini arranges the components of his scenes very freely, achieving a highly dynamic sculptural effect. Apart from the license he takes with perspective in portraying the pillar and partly ruined arches that divide up the surface, in engraving the figures he also makes them stand out to different degrees, according to how far they are from the spectator. In so doing he was adopting a device that had been used by Florentine

artists since the time of Donatello and Ghiberti; one that was also used by Sansovino in the bronze door at St Mark's in Venice.

It was actually at Cardinal Ferrara's house that the idea and model for the famous *Salt-Cellar* were born. Although the work was ultimately executed for King François I of Valois, it was presented as a model to the Cardinal. Cellini describes it in his autobiography in great detail: "I made an oval shape, a good bit more than half a cubit in size - in fact almost two-thirds - and on it I modeled two large figures, to represent the Sea embracing the Land. They were a good deal more than a palm in size, sitting with their legs entwined in the same way as certain long branches of the sea cut into the land. In the hand of the male figure, the Sea, I put a very richly ornamented ship, that could easily and conveniently take a good quantity of salt; underneath him I positioned the four sea-horses, and I placed the trident in his right hand. I represented the Land by a women, whose beauty of form was such that it demanded all my skill and knowledge. She was beautiful and graceful, and by her hand I placed a richly ornamented temple; it was placed on the ground, and she rested her hand on it. I made this to hold the pepper. In her other hand I put a horn of plenty, adorned as exquisitely as I knew how. Beneath this goddess, on the part which was meant to be the earth, I grouped all those wonderfully beautiful animals that the earth produces. Corresponding to this, I fashioned for the Sea every kind of beautiful fish and shell that the small space could contain. The rest of the oval I filled in with a host of rich designs" (p.239).

The Cardinal was astounded by the model, not only on account of the beauty of the whole composition, which was clearly a monumental piece even in its design stage, but also in view of the goldsmith's courage in taking on a huge job that would have involved enormous expenses since Cellini hoped to make it in gold. His angry comment was: "If you don't make it for the King, to whom I'm taking you, I don't think it can be made for anyone else" (p. 240).

What strikes the latter-day reader is the way Cellini always wanted to create the most fantastically magnificent and precious objects for his clients, things that would astonish even those contemporaries who were used to a degree of opulence that is unthinkable today. His absolute lack of qualms in suggesting such sophisticated designs provides an interesting insight into the times in which he and Michelangelo both lived: as the political situation gradually began to lose its balance everything and anything began to seem possible. Artists began to compete with the achievements of the previous generations, gaining inspiration from their own recent history but without yet succumbing to the stylistic constraints of what was later to become Mannerism.

Granted, the complexity of Cellini's approach to his work, the elegance of his forms and the witting skill of his executions can in some respects be seen as

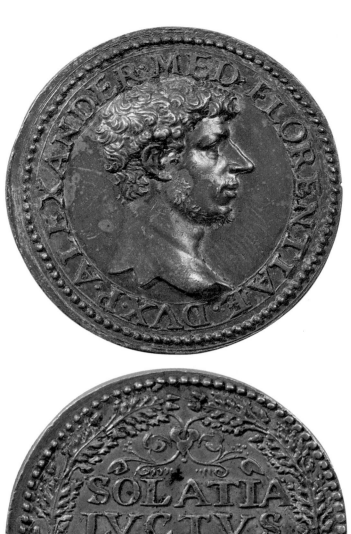

19. Benvenuto Cellini
Medal of Alessandro de' Medici, obverse side
diam. cm. 3.6
Florence, Bargello Museum

20. Benvenuto Cellini
Medal of Alessandro de' Medici, reverse side
Florence, Bargello Museum

Mannerist, in the broadest sense of the term. Yet his creations also have a balance and a kind of cold sobriety that are still far removed from the kind of self-indulgent intellectual intricacies that were ultimately to empty the images of all meaning, turning them instead into coded allusions to something they no longer even represent.

On the way to France Cellini stopped off in Ferrara again, where he made a portrait of Ercole II d'Este (1508-1559) "on a round piece of black stone, about the size of a little dinner plate" (p. 246). On the reverse he showed Peace setting alight a pile of weapons with a torch, with Fury beneath in chains, accompanied by the motto: PRETIOSA IN COSPECTU DOMINI.

It seems probable that here again Cellini used that mixture of bleached wax and powdered white lead that he mentions in his treatises to make the die. Certainly a plaster mold for casting was made from one of his medals for Ippolito d'Este by one Francesco delle Nappe, who was paid for his work on 14 April 1540. This technique is likely to have been used for other medals dating back to the same period, so they too would have been cast rather than struck. In this sense

21. Benvenuto Cellini
Lead stamp of the Seal made for Cardinal Ippolito d'Este
cm. 11x8
Lyon, Musée des Beaux-Arts

22. Lauzio di Meo
Original mold of the Seal of Cardinal Ippolito de' Medici with the same field as that of Giulio de' Medici
cm. 10.9x7
Florence, Bargello Museum

they differ from two earlier medals that are generally attributed to Cellini: the one of Bembo, the best silver specimen of which is kept at the Bargello Museum in Florence; and the one of François I of Valois that is thought to have been made during the artist's first stay in France. There is a single-sided proof kept at the Goethe Museum in Weimar that may well derive from the medal of Ercole II, but as in the case of the Bembo medal, the attribution cannot be entirely certain.

Cellini's second experience with the French court was not initially much better than the first. Cardinal Ferrara tried to get the artist to travel to Paris post haste, having assured the King that he was currently sick in Lyons. However, Cellini did not oblige, but rather made his way there in comfortable stages once he had left Ferrara. This disobedience probably irked the prelate, who certainly promoted Cellini at the court of François I, but proposed an annual allowance that Cellini dismissed as insultingly low. Luigi Alamanni, who was a true friend to Cellini, was part of the Cardinal's retinue, and it was probably thanks to him that a better contract was stipulated: seven hundred crowns a year as well as payment for all the individual items commissioned by the King.

On the first day of January 1540 François I of Valois had given Charles V, then traveling through Paris, a silver Hercules between two columns, which was the Emperor's heraldic device. The life-sized statue had been designed by Rosso and was the work of Parisian goldsmiths. The King thus decided to get Cellini to chase twelve more figures of gods and goddesses in silver to serve as candlesticks.

In a room belonging to Cardinal Ferrara Cellini made four small models in wax of Jupiter, Juno, Apollo and Vulcan. On the basis of these he was allowed to hire his two assistants at a salary of one hundred crowns each. Moreover he was also given permission to install himself in a castle known as the Petit Nesle on the left bank of the Seine, just near the walls. This actually proved more difficult than was expected, but by 1541 he was able to set up his workshop there, along with his own quarters and those of his assistants.

When at last he had finished the jug and the oval bowl for his Italian patron, Cellini set to work on the models for Jupiter, Vulcan and Mars, making them exactly the same size as they were to be in silver. Shortly afterward the King was also able to see for himself how well these figures were progressing in the artist's workshop, where one man was beating out the head and another the legs, while Cellini himself was busily working on the body of the Jupiter.

On March 17 of the year 1541, at the end of a court banquet Cardinal Ferrara presented François I with a gift: the jug and bowl made by Cellini. Those present, including the King's favorite Madame d'Étampes, were thus able to see what the artist was capable of. The

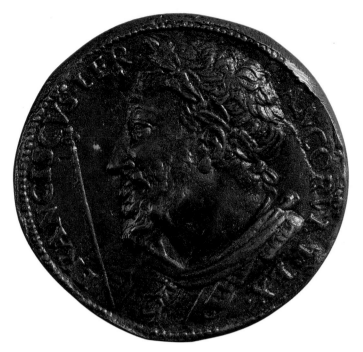

following day the King summoned him to his presence and said that he would like a fine salt-cellar to keep the gilded silver bowl and jug company, at which point Cellini promptly proposed the model that he had already made for Ferrara. The King was enchanted by the design and ordered the necessary amount of gold to be made available. Since the silver figure was being made with the chasing technique and without recourse to metal molds, Cellini wished to work on it himself, believing the local craftsmen to be too crude to be reliable. He thus hired Frenchmen and Germans to start work on the salt-cellar.

As if this were not enough, he also decided to use some of the surplus silver to make a large vase with two handles and to cast in bronze the large model he had made for the silver statue of Jupiter. For this latter task he turned to Parisian craftsmen, who ended up by botching the job for lack of skill. Apart from all this Cellini also began on a head of Julius Caesar, "...a bust in armor and much larger than life-size. I copied it from a little model I had brought with me from Rome" (p. 265). Moreover he "also began work on another head of the same size, but this time I used as my model a very beautiful girl whom I kept to satisfy my sexual appetites" (p. 265).

Although we do not know for sure that the two heads were ever actually finished, let alone cast in bronze, the fact that they are mentioned bears witness to Cellini's ambitions with regard to statuary as such, particularly once the King had commissioned him to create candlesticks which were to be over two meters tall.

Cellini was probably anxious to oust and replace Primaticcio, the artist known as "Bologna" so favored by Madame d'Étampes, whose rooms at Fontainebleau he had been embellishing with sensuous plasterwork since 1541.

At the Petit Nesle Cellini set up a furnace so that he could cast the bronze base of the Jupiter, decorated with a low relief showing the rape of Ganymede and Leda and the Swan, the Juno and a number of other works in bronze which he describes in detail. However, before dealing with Cellini's colossal engagements, mention should be made of the fact that the real version of the salt-cellar does not entirely conform to the model originally made for Cardinal Ferrara. For instance, in the final version the figures are seated on turquoise cloths decked with golden fleur de lys; moreover, the niches of what is known as the Ionic temple have been embellished with oval medallions bearing the royal insignia. As for the temple itself, it is more like a triumphal arch in the style of Sebastiano Serlio, the chief architect at Fontainebleau. So attentive was Cellini to his new patron that beneath the earth he even introduced the white elephant so dear to François I.

Cellini's *Life* contains a second description of the salt-cellar, but not even this entirely corresponds to reality. In fact in the finished object the female figure is not holding a cornucopia, as the artist claimed. Yet he does provide much more detail regarding the base of the piece: "I had then given the work a foundation, setting it on a black ebony base. It was of the right depth and width and had a small bevel on which I had set four gold figures, executed in more than half relief, and representing Night, Day, Twilight, and Dawn. Besides these there were four other figures of the same size, representing the four chief winds, partly enameled and finished off as exquisitely as can be imagined" (p.291). Clearly Cellini was deliberately echoing Michelangelo, whose work was well known at the French court through drawings brought there by Antonio Mini and the Hercules that belonged to the royal collections. As for the two recumbent male

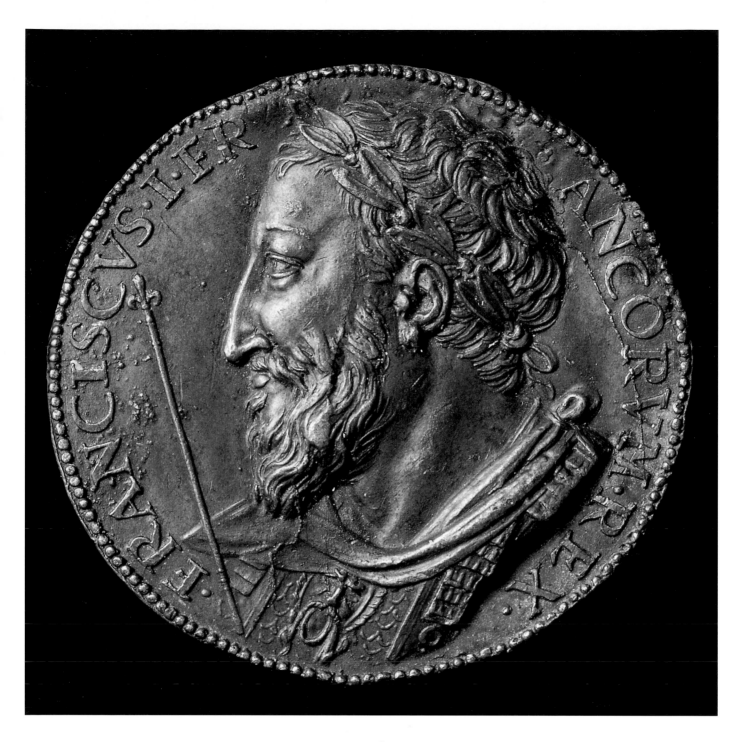

23. Benvenuto Cellini
Cast bronze medal of François I, obverse side
diam. cm. 3.8
Florence, Bargello Museum

24. Benvenuto Cellini
Medal of François I showing the King triumphing
over Fortune, reverse side
Florence, Bargello Museum

25. Benvenuto Cellini
Silver medal minted for François I
diam. cm. 4.2
Cambridge, Fitzwilliam Museum

figures that decorate the wooden base and support the whole composition, they are practically plagiaries of Michelangelo's two marble statues in the Sagrestia Nuova at San Lorenzo. By contrast, the female figures portraying Night and Dawn testify to Cellini's own creative originality. All of these embellishments, including the personification of the winds, would appear to be directly related to his stays in Rome and the cities of the Po valley, when he would have become familiar with the works of the Raphael school.

Cellini must have carried a great deal of documentary material around with him, including drawings of statuary, ancient and modern, engravings and many of his own drawings. In fact he kept these latter until well into old age, when he may well have used them

17

to describe the works he created in France or had not seen for a long time. According to a number of scholars this accounts for the discrepancy between his descriptions of the gold *salt-cellar* and the object itself. Moreover, it would be perfectly in keeping with the customs of other goldsmiths and metal artists of the time.

It is hard to conjure up an idea of just how other pieces of tableware made by Cellini for illustrious Parisian clients must have looked. He worked on items for Piero Strozzi, for the Count of Anguillara, for the Count of Pitigliano, for the Count of Mirandola. He also recalls having secretly worked on a vase for Madame d'Étampes, but in the end became so impatient with her rudeness and evident hostility that he gave it to the Cardinal of 'Loreto' instead. Since the Cardinal insisted on reciprocating this gift with the considerable sum of a hundred gold crowns, it is reasonable to believe that the item in question would have been finely chased with decorative scenes.

In 1542 Cellini was finally able to work on a truly monumental project: the doorway of the palace of Fontainebleau, the King's favorite residence. This time it was Madame d'Étampes who had suggested such a commission to the King.

"First of all I had made a model for the doorway of the palace of Fontainebleau, slightly correcting its proportions, as it was wide and squat in that bad French style of theirs. The opening of the doorway was almost square, and above it there was a half-circle, squashed like the handle of a basket. In this half-circle the King wanted to have a figure representing Fontainebleau. I made a beautifully-proportioned doorway, and then I placed over it an exact half-circle. At the sides I designed some charming projections, with socles underneath to match the cornices above. At each side, instead of the two columns usually found with this style, I had two satyrs. One of them stood out in rather more than half relief, and with one of his arms was making as if to hold up the part of the doorway which would have rested on the column; in the other hand he was grasping a heavy club. He looked very fierce and aggressive and was meant to strike terror into the beholder. The other satyr had the same stance, but the head and several things of that sort were different. He was holding a whip, with three balls attached to some chains. Although I call them satyrs, they had nothing of the satyr about them except for their little horns and goats' heads, otherwise they looked like humans. In the half-circle I had made a woman reclining in a beautiful attitude; ... I had enclosed the whole work in an oblong, and in each of the upper angles I had designed a Victory, in low relief, with torches in their

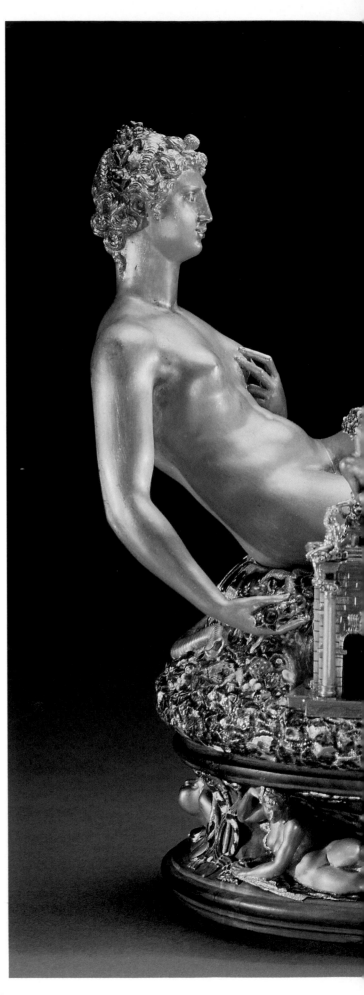

26. Benvenuto Cellini
François I's Salt-Cellar
cm. 26x33.5
Vienna, Kunsthistorisches Museum

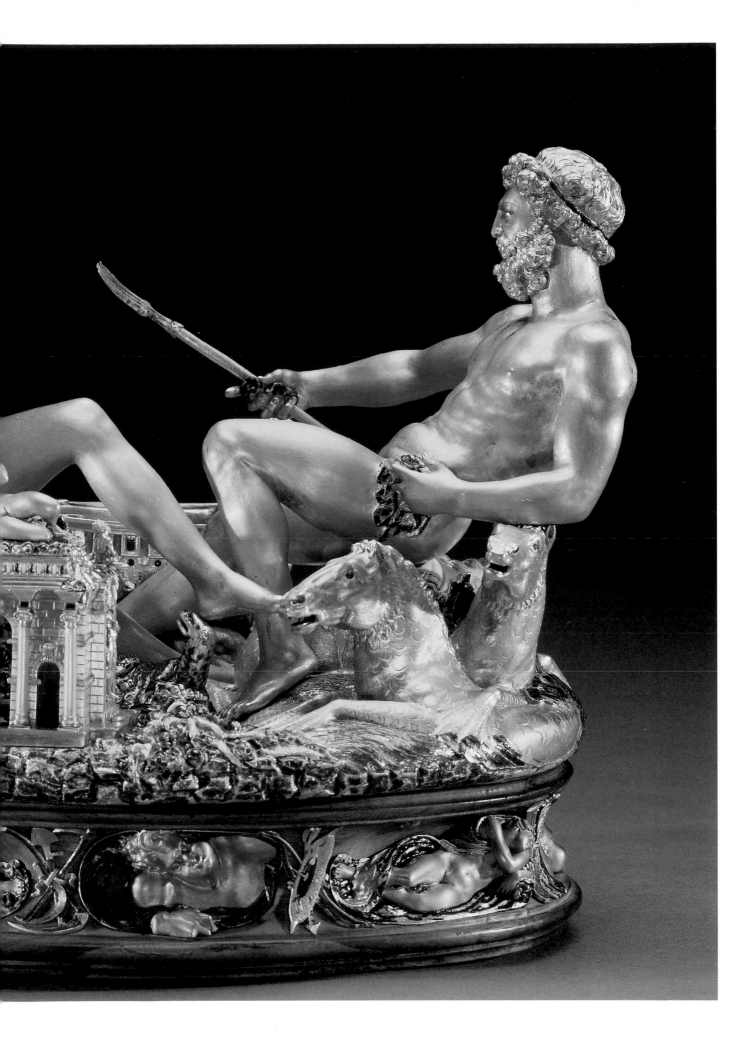

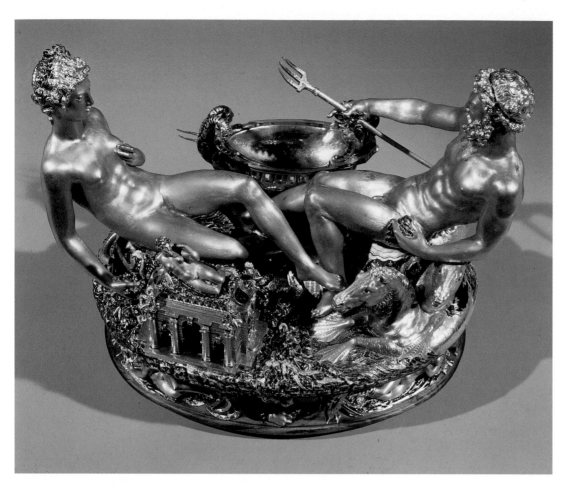

27,29. Benvenuto Cellini Salt-Cellar and detail of the ship Vienna, Kunsthistorisches Museum

28. Baccio Bandinelli Adam and Eve Florence, Bargello Museum

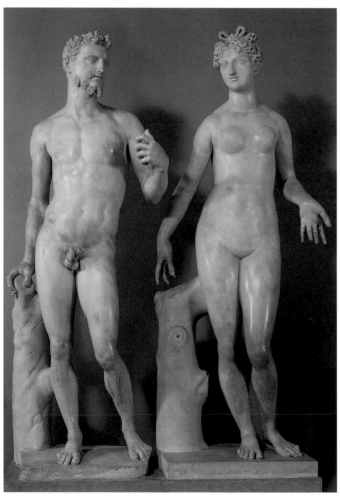

hands as we see in the representations left by the ancients. Above this I had shown the salamander, the King's own device, and a host of other charming ornaments all harmonizing with the work, which was in the Ionic style" (pp. 269-270).

Cellini's description of the design of the doorway could not be clearer, and although the project was not finished before he left France, he recalls having shown the King the assembled parts all ready to be cast in some large rooms on the ground floor at the Petit Nesle. In the end the lunette was the only part to have been cast and finished. Now kept at the Louvre, it embodies a number of stylistic elements that were typical of the period, such as the extremely elongated body of the nymph and her clear-cut, somewhat geometrical profile, the coils of water that pour out of the decorated vase beneath her left arm, and the highly descriptive portrayal of the animals that surround her.

Many of these stylemes and motifs were common to the artistic and decorative products of the school that developed at the French court at Fontainebleau. In fact certain of the decorative devices, some of them truly excessive, are to be found in the work of other masters who worked for François I. A case in point is the stand for an antique vase that was designed by Tribolo and is still *in loco*: the attributes of Artemis of Ephesus have been adopted in highly explicit terms to create a Goddess of Nature that is unquestionably one of the most intriguing iconographic products of the esoteric interests of the French court. Cellini often

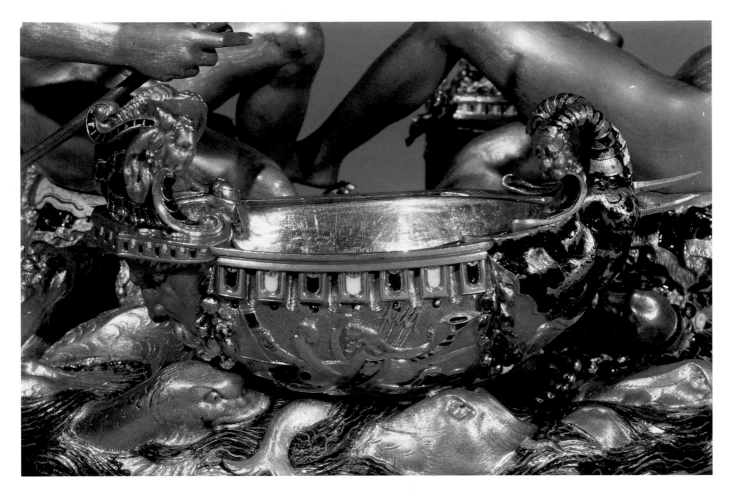

insisted on his use of real life models "seeing that nature is the only book from which we can learn art" (p. 318), relating how he based his Nymph on a certain Caterina, who was also his lover, as well as availing himself of the services of another fifteen year-old girl, who bore him his first child. Yet the sculpture itself also deliberately speaks for the artist's knowledge of classical statuary.

That the King was interested in antiquities is also clear from the fact that he commissioned Primaticcio to go to Rome to have molds and bronze casts made of the Belvedere statues, from the *Laocoon* to the famous *Apollo*. As Cellini relates, these copies were then arranged in the great gallery at Fontainebleau. Since by this time he featured in the royal account books as a sculptor as well, it must surely have been to keep up with the other court masters that he added the boor's head on the left of the composition. Clearly it derives from the Hellenistic marble sculpture now kept at the Uffizi that must once have belonged to a group portraying Meleager hunting.

Among the various elements that can help us reconstruct Cellini's project, mention should be made of the pair of lightly veiled wingless *Victories* holding torches as in an ancient triumphal arch and surrounded by swirling drapes. There are plaster versions of these reliefs at the Louvre that are certainly taken from Cellini's originals and that give an idea of what he had in mind in sculptural terms. Here again only the head and lower extremities of the figures jut out strongly, whereas all the rest follows the models of the reliefs of the Augustan age, emerging from and melting into the background to create different effects. Even Cellini's own description of the work in his *Life* explicitly records how the two satyrs that replaced the two columns usually found with this style stood out "in rather more than half relief", though not full relief. This was a fairly predictable corrective solution to what Cellini saw as an excessively squat design on the part of the French architect Le Breton, whose work lacked the lift of Italian buildings that followed the proportions of classical architecture.

In fact in the drawing of one of the satyrs belonging to the Ian Woodner's family collection in New York the shading relating to the back, the raised right arm and left hand holding the club suggests a figure in high but not full relief. Scholars believe it to be by Cellini himself, not least on account of comparisons with the Louvre drawing of *Juno* designed for the series of candlesticks for François I. Bearing this in mind, the bronze sculpture at the J. Paul Getty Museum in Malibu seems less likely to be the work of Cellini, and more probably a later copy modeled on memories of Cellini's work.

Moving from small scale works to monumental projects is unlikely to have been as swift and easy an evolution as Cellini would like to make out in his autobiography. We know that the two larger than life-size heads that he modeled shortly after establishing himself at the Petit Nesle were also cast in bronze. The

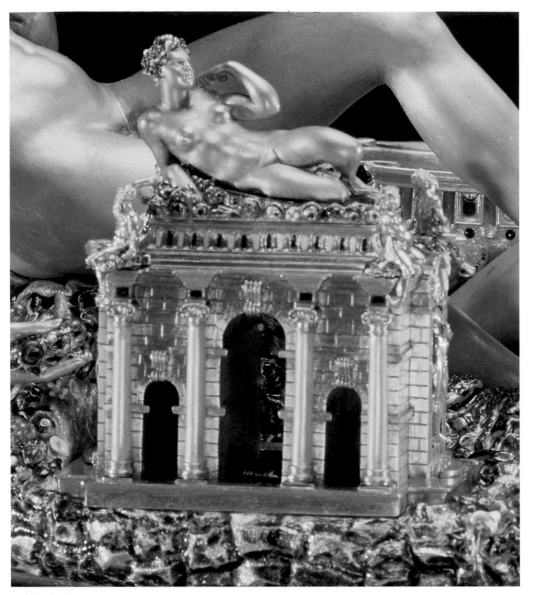

30-32. Benvenuto
Cellini
*Salt-Cellar and details of
the little temple and one
of the figures of the
winds
Vienna,
Kunsthistorisches
Museum*

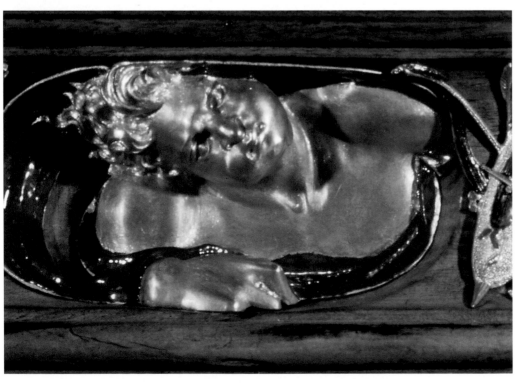

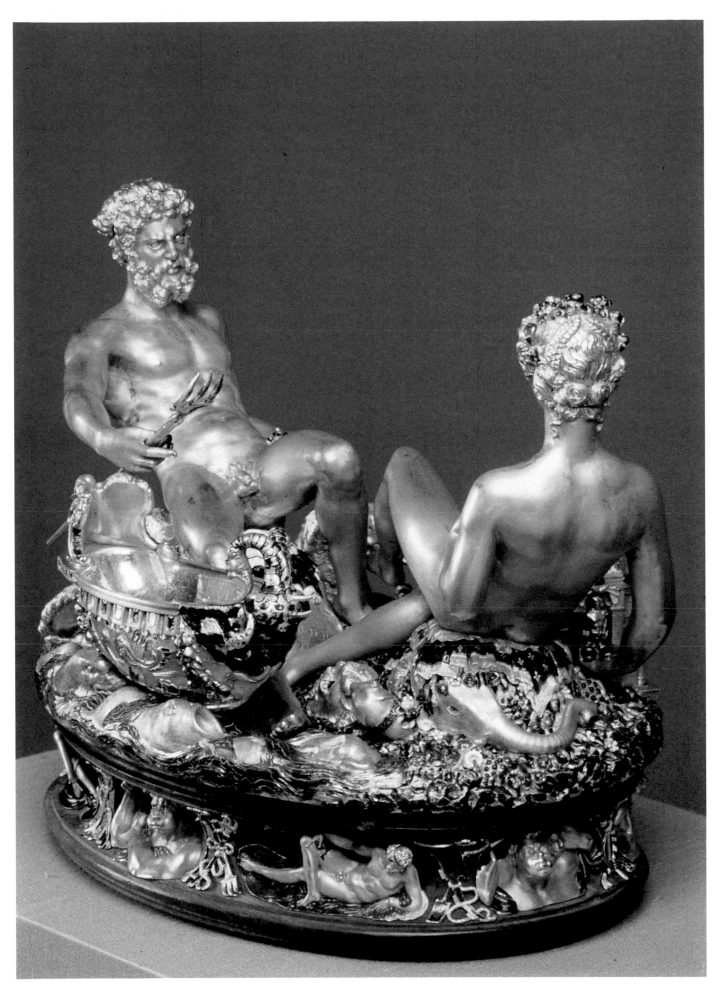

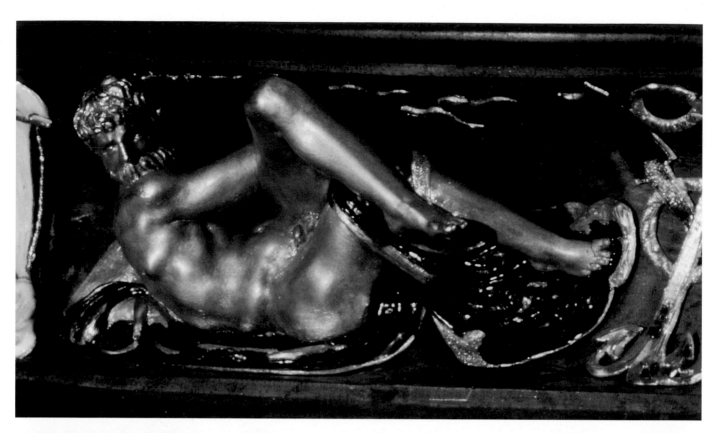

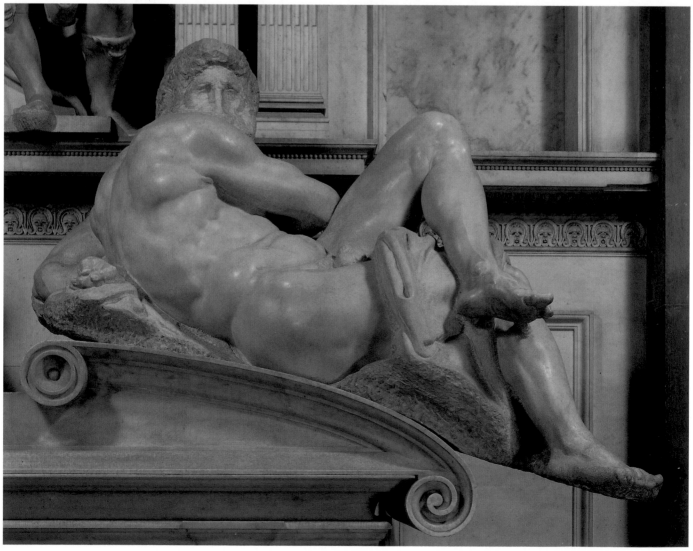

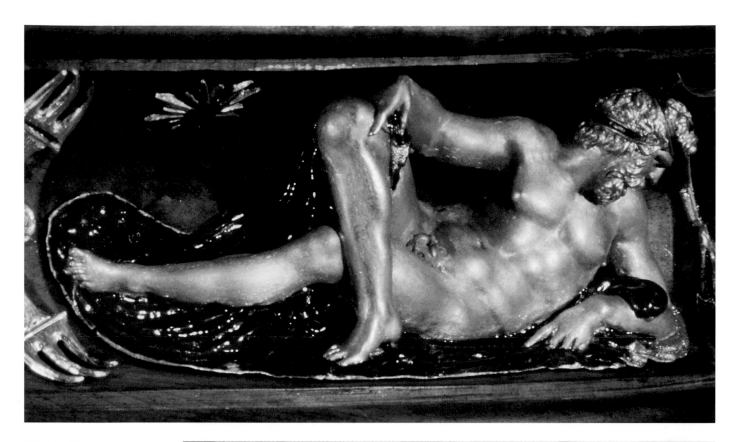

33,35. *Benvenuto Cellini*
Salt-Cellar, detail of the figures of Dusk and Day
Vienna, Kunsthistorisches Museum

34,36. *Michelangelo*
Dusk and Day
Florence, Medici Chapels, Sagrestia Nuova

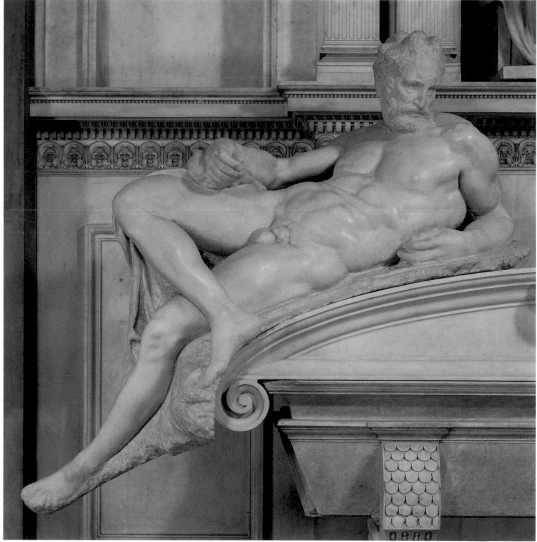

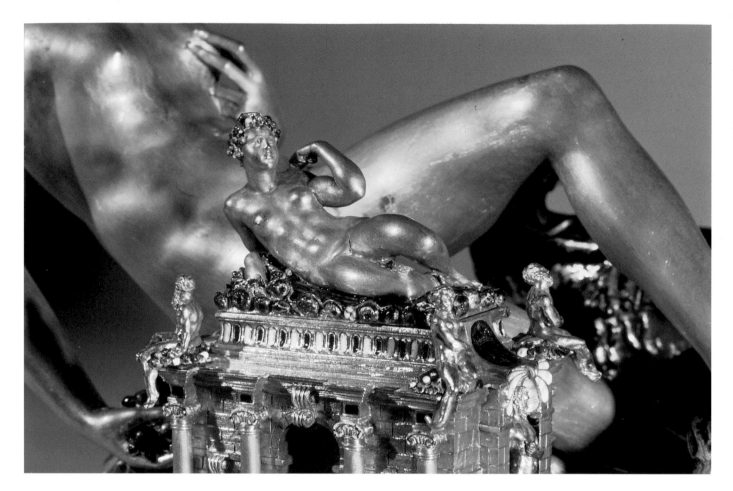

37. Benvenuto Cellini
Salt-Cellar, detail of the female figure on the little temple
Vienna, Kunsthistorisches Museum

fact that no trace of them remains rather suggests that they were not held to be particularly interesting by Cellini's contemporaries. Cellini justifies the operation by saying that he simply wanted to find out more about local clays and casting techniques. However, it is reasonable to imagine that he was also aware of his own technical and formal shortcomings and intended to overcome them at his own expense by working on more demanding projects than he had hitherto addressed as a supremely skillful goldsmith.

This is the framework within which Cellini also drew up his designs for the fountain of Mars for François I. The god of war was to be portrayed not as a destroyer but rather as a protector of the virtues representing Learning, Design, Music and Liberality, portrayed below.

Shortly before leaving for Italy Cellini did more work on a colossal Mars, a figure that he mentions on various occasions in his *Life*. "I had constructed it on a nicely fitted wooden frame, over which there was a crust of plaster, an eighth of a cubit deep, cleverly made for his flesh. Having seen to that, I had begun to cast the figure in several pieces which were afterwards to be dovetailed together in the right way; and this proved very easy to do" (p. 299).

The fact that the King gave Cellini his first dressing-down when he visited his studio for the presentation of the Fontainebleau doorway and the colossal statue (which was apparently to be fifty-four feet high) rather suggests that he did not actually like it very much,

although he ordered it to be sheltered from bad weather in 1546 on the understanding that Cellini would return to Paris to finish it. The reprimands consisted in pointing out how the artist had been given complete free rein, but had repaid the sovereign with only one of the twelve silver figures which he had originally commissioned.

Certainly Cellini had not entirely obeyed the royal orders, having done his utmost to obtain commissions for increasingly prestigious works that were far removed from the skills for which he had been given an allowance at court. Nevertheless, the silver Jupiter that he had presented to admiring viewers at Fontainebleau had proved to be a triumph, even though it elicited the usual tiff with Madame d'Étampes.

"I brought my Jupiter in (to the gallery at Fontainebleau); and then, when I saw such a splendid spectacle with everything so skillfully set out, I said to myself: 'This is certainly running the gauntlet - now God help me'. I put it in its place, positioning it as well as I could, and I waited for the arrival of the great King. In Jupiter's right hand I had placed his thunderbolt, so that it looked as if he were about to hurl it;

and in his left I had placed a globe. Among the flames I had very neatly introduced a length of white taper. Madame d'Étampes had managed to keep the King distracted till nightfall, with the intention of ensuring one of two unfortunate results for myself - either his not coming at all, or, because of the darkness, my work's being shown at a disadvantage: but, as God rewards those of us who trust in Him, quite the opposite happened, because seeing that it was growing dark I lit the taper that the Jupiter was holding, and as this was lifted a little way above the statue's head its light fell down from above, making the work appear much more beautiful than it would have done in daylight. The King appeared on the scene along with his Madame d'Étampes, the Dauphin his son and the Dauphiness... I had my assistant, Ascanio, push the beautiful statue of Jupiter forward in his direction; he moved it very gently, and since I had done the job very skillfully and the figure was very well constructed this slight movement made the statue seem alive. The antique statues were left somewhat in the background, and so my work was the first to delight the spectators" (pp. 297-298).

Other contemporary accounts substantially back up Cellini's version of the events. Indeed, when the King's favorite insidiously suggested that the artist had draped a fine cloth woven with silver and gold yarns over the statue to cover up some fault, Cellini tore it off the statue revealing its fine genitals and asked her ladyship if she found fault in what was displayed before her. This response with its surely deliberate double meaning must have elicited smiles among the bystanders and indeed from the King, who was not above appreciating such witticisms even if they smacked of irreverence. Thus Cellini was able to prove his worth in both art and repartee.

Cellini celebrated the personal satisfaction that this occasion gave him by presenting his collaborators back in Paris with gifts of various sorts. Yet the situation cannot have been particularly easy, especially given that the time that he himself had devoted to executing the first of the twelve figures was quite out of proportion with respect to the outcome, which he measured more in terms of artistic immortality than immediate personal gratification. Everyone was aware of the fact that works in precious metals were less likely to survive in time because there was always the risk that they might have to be melted down or substantially changed in order to deal with unforeseen financial demands. This explains why Cellini showed little enthusiasm for the project, and indeed why so little of it has come down to us. We have already discussed the design for the figure of Juno. However, mention should also be made of the small bronze belonging to a private collection in Paris: it is about twenty-five centimeters tall and appears to echo the three-dimensional figure of the goddess.

Strangely enough Cellini never mentions having developed a model for the statue of the goddess. Yet

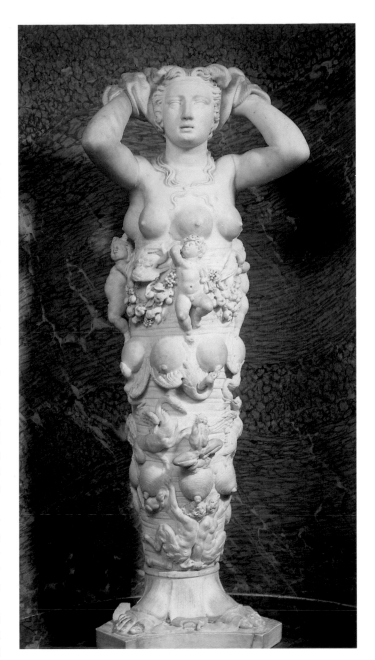

38. Tribolo
The Goddess of Nature
Paris, Fontainebleau

scholars have hitherto believed that he must have done the Louvre drawing after modeling the prototype on a smaller scale, not least since that he tells us that he cast the bronze base for this figure at the same time as he did the one for the Jupiter. However, the slight discrepancies between the model and the drawing rather suggest that they belong to two different moments in the development of the design, with the drawing following the model. The reason for casting the statuette in metal was that the colossal silver candlesticks took so long to make that it was a good idea to keep a model that could stand up to the wear and tear of the workshop. In fact the reference to the attempted bronze cast of the Jupiter would seem to corroborate

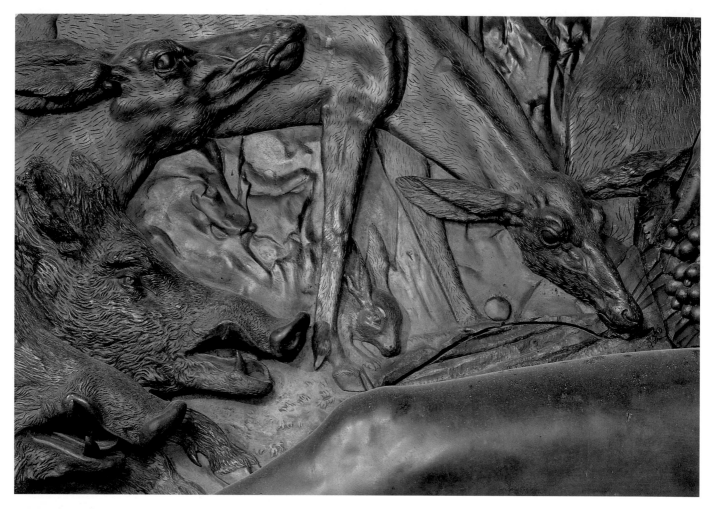

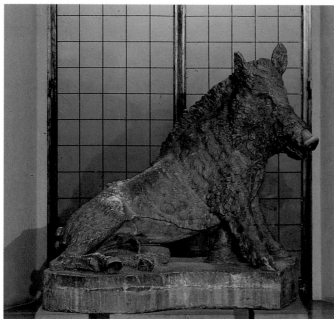

39. Benvenuto Cellini
Fontainebleau Nymph, detail
Paris, Louvre

*40. Wild boar that once belonged to Paolo Ponti
and was given by Pius IV to Cosimo I (copy of
Hellenistic original)
Florence, Uffizi Gallery*

this hypothesis as well as explaining the existence of other small bronzes that do not differ greatly from Cellini's own designs.

In 1545 Cellini was finally able to show the three beautifully chased vases to François I, who ordered them to be gilded to enhance the relief work and make them more precious. At this point he beseeched the King for permission to return to Italy for a short stay, promising that he would return to the court just as soon as the economy had picked up following the end of the war with England, when his royal patron would also be able to contemplate projects other than military ones once more.

Without waiting for an official answer and relying instead on the good offices of Cardinal Ferrara, to whom the King had entrusted him for all necessities, Cellini left his workshop in the hands of his Italian apprentices and set off for Lyons, where he claims that he intended to leave the three silver vases. Since the metal for only one of them had been paid for, to some extent they still actually belonged to him. He was thus surprised when one of the Cardinal's men caught up with him and said in the King's name that he was wrong to have abducted crown property. So the vases were duly made over to the emissary and Cellini continued on his way toward Italy, against the better judgement of other members of the court and gentlemen he met en route. After stopping off in

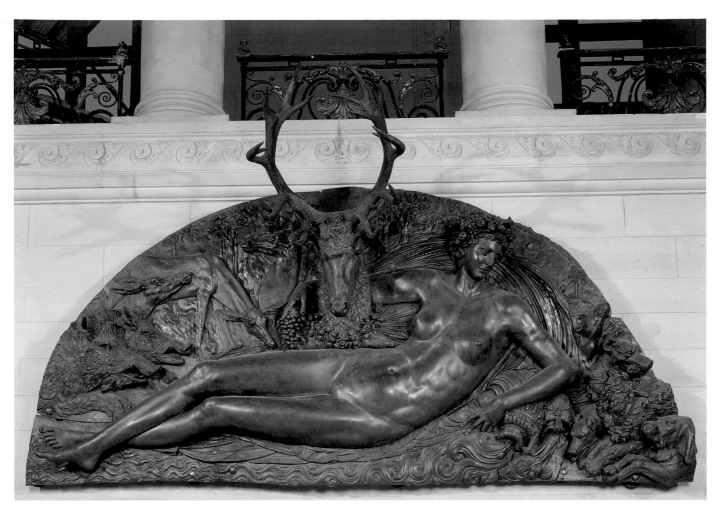

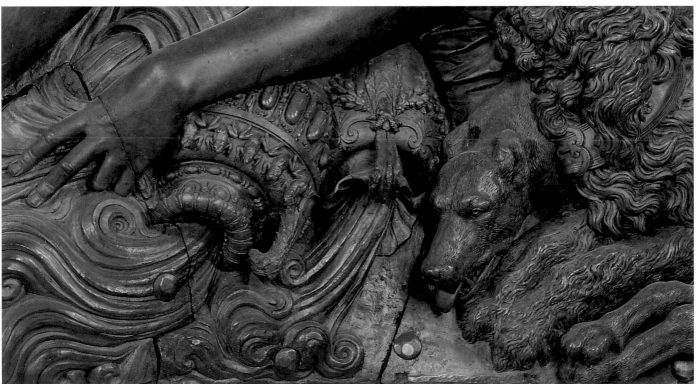

41, 42. Benvenuto Cellini
Fontainebleau Nymph
cm. 205x409
Paris, Louvre

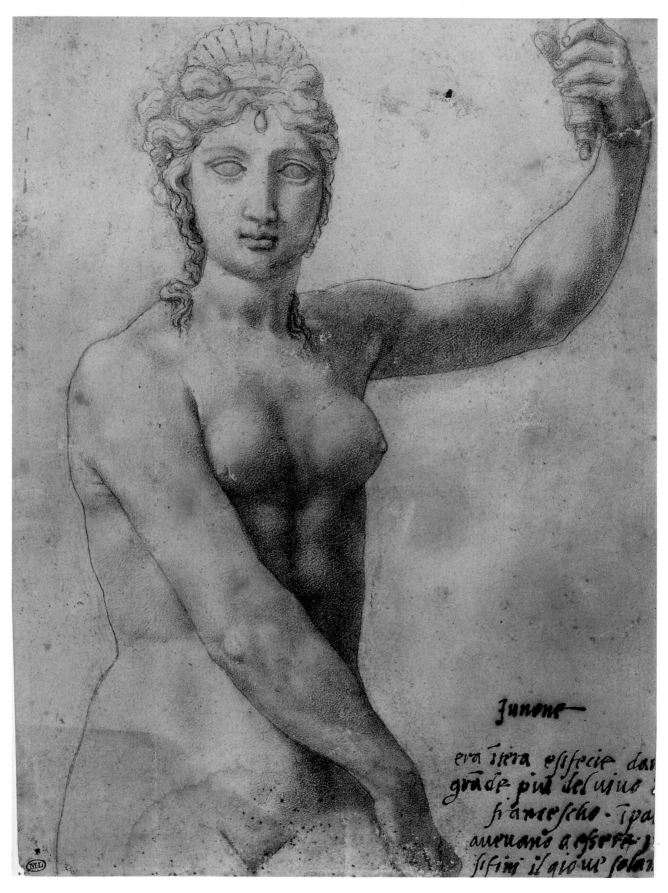

Junone —

era itera esifecie dai
grāde piu delvino
fiancesche Tpa
avenano aesser
sifini il aiour sola

43. Benvenuto Cellini
Drawing for the statue of Juno
cm. 24.7x18.6
Paris, Louvre

44. Benvenuto Cellini
Drawing of a Satyr
cm. 41x20.2
*Washington, National Gallery of Art (previously
in a private collection in New York)*

30

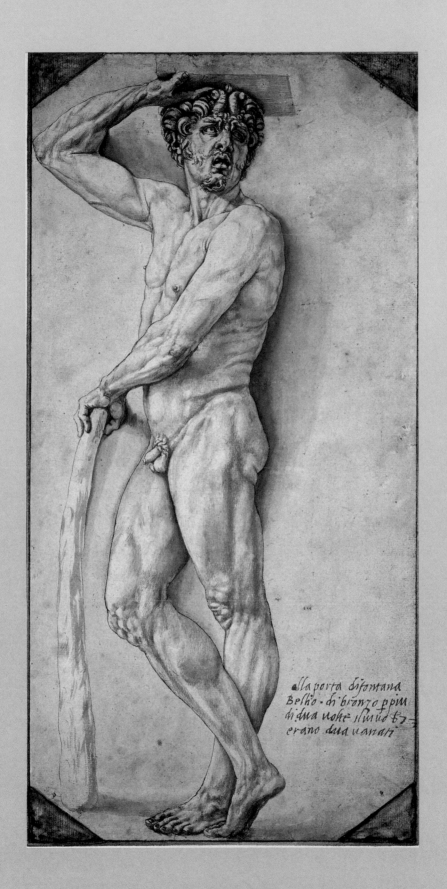

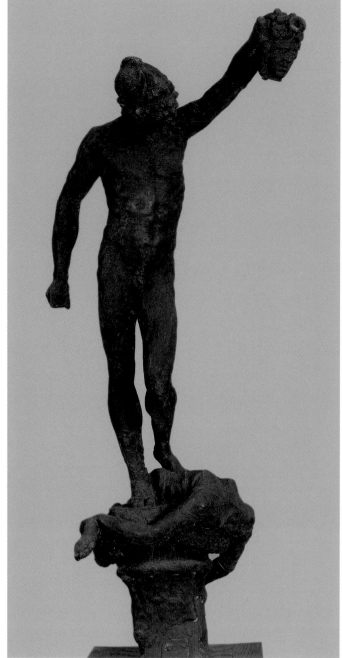

Parma, where he paid his respects to Pierluigi Farnese, who had once been his enemy at the Papal court, he finally reached his home town of Florence.

At this point Cellini's account of his life changes in tone, doubtless as a reflection of the enormous changes in his circumstances.

"At that time our Duke of Florence was at Poggio a Cajano, a place ten miles distant from Florence: it was the month of August, 1545. I went there to find him, with the sole purpose of paying my proper respects..." (p. 312). Cellini then goes on to relate how the Duke welcomed him with great affection, was astounded to hear about his deeds in France, and proposed that he should stay in Florence as the court sculptor and goldsmith.

"Then I, poor wretch, in my eagerness to show the splendid Florentine school that since my departure I

45,46. Benvenuto Cellini
Wax model of Perseus
cm. 72
Florence, Bargello Museum

47. Benvenuto Cellini
Bronze model of Perseus
cm. 75
Florence, Bargello Museum

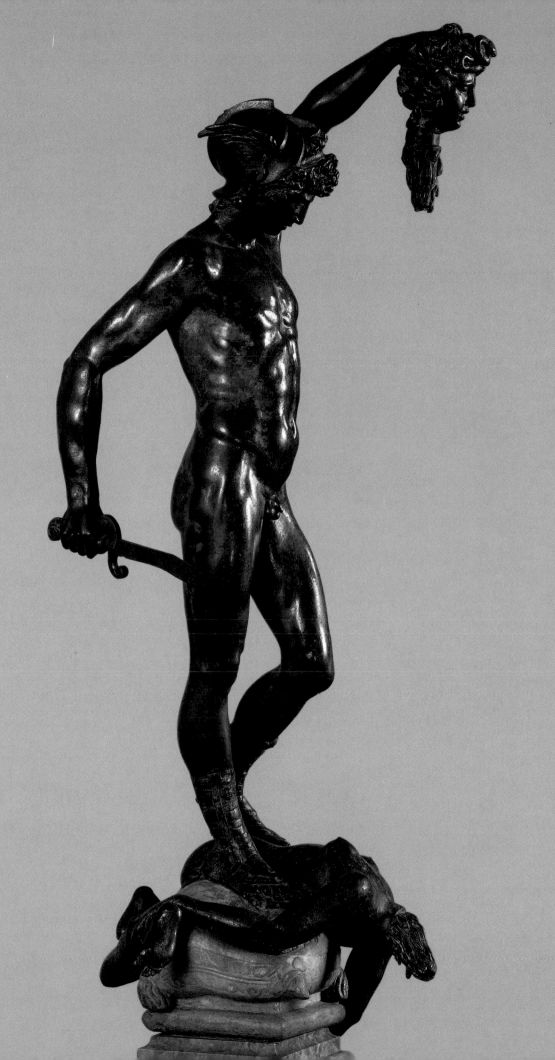

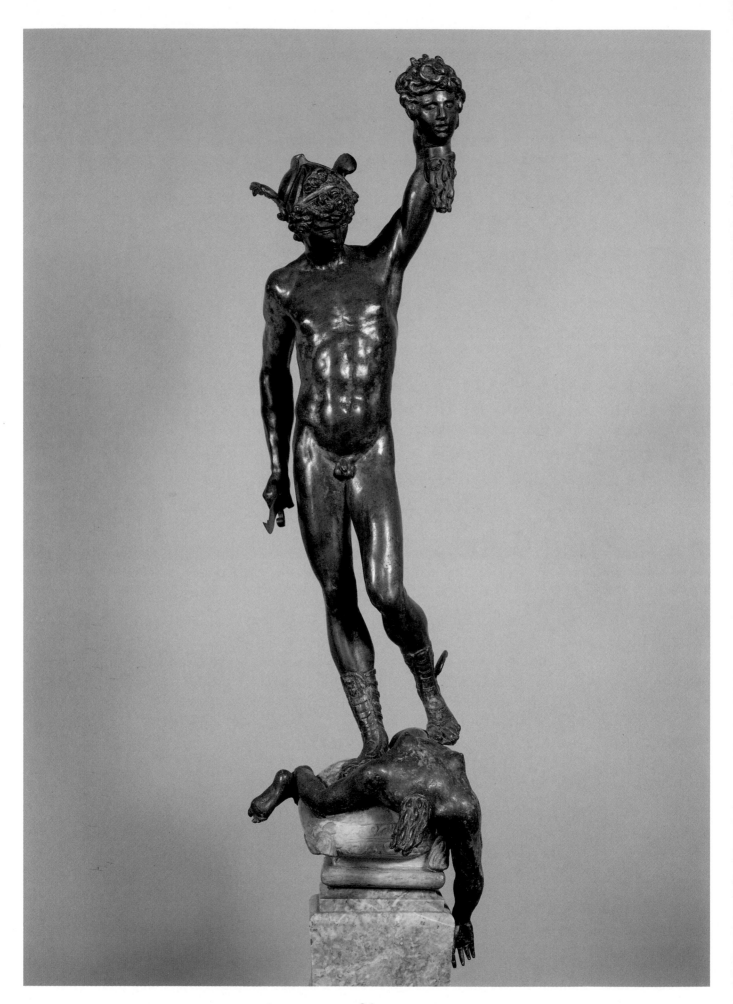

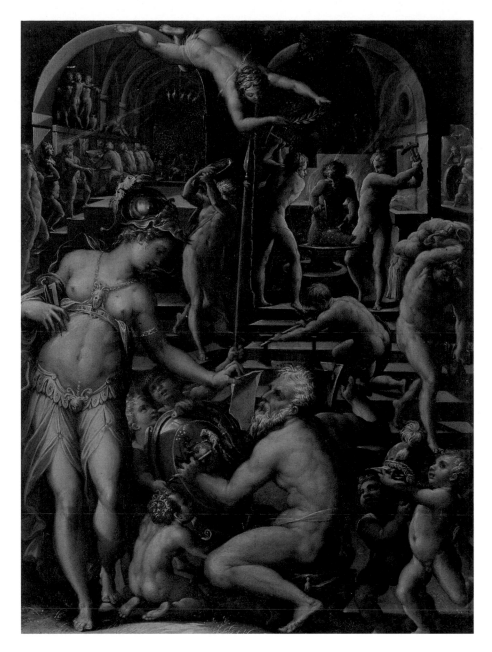

48. Benvenuto Cellini
Bronze model of Perseus
Florence, Bargello Museum

49. Giorgio Vasari
Vulcan's Forge, detail of presumed portrait of
Cellini in the guise of Vulcan
Florence, Uffizi Gallery

had been engaged far more than it imagined on other branches of art, said in reply that I would be only too pleased to make him a great statue, either in marble or in bronze, for that fine piazza of his. He answered that all he wanted as my first work for him was a Perseus; he had been wanting this for a long time, and he begged me to make him a little model of it" (p. 313).

Cellini makes it quite clear that the reason he accepted Cosimo's proposal was not because he re-quired the favor of a patron, but rather so that he could show his fellow citizens that he too had become a first-rate sculptor on a par with Donatello or Michelangelo, whose works dominated the embellish-ments of Piazza della Signoria. Compared with the *David*, Bandinelli's *Hercules and Cacus*, though in itself a good work, looked like a sack of potatoes or marrows to the Florentines. In fact they ridiculed the sculptor and his creation with a hundred offensive sonnets. Cellini was sure that he could do better, es-pecially in bronze, by creating a figure or a group that would be larger than the *Judith* and also better ex-ecuted. At the time the biggest metal sculptures were the ones at Orsanmichele, the last of which had been cast by Baccio da Montelupo. With its many drapes there is no doubt that it must have seemed stylistically very dated to the mid-sixteenth century eye. Michelangelo had changed contemporary perceptions by bringing back the nude in all its imposing dignity: no longer the emaciated, ascetic personification of

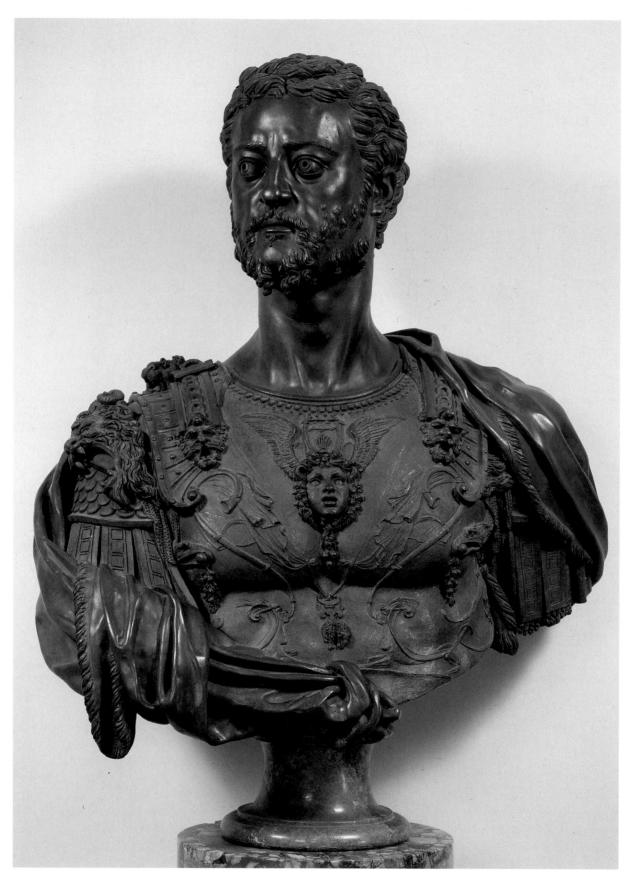

50, 51. Benvenuto Cellini
Bust of Cosimo I
cm. 110
Florence, Bargello Museum

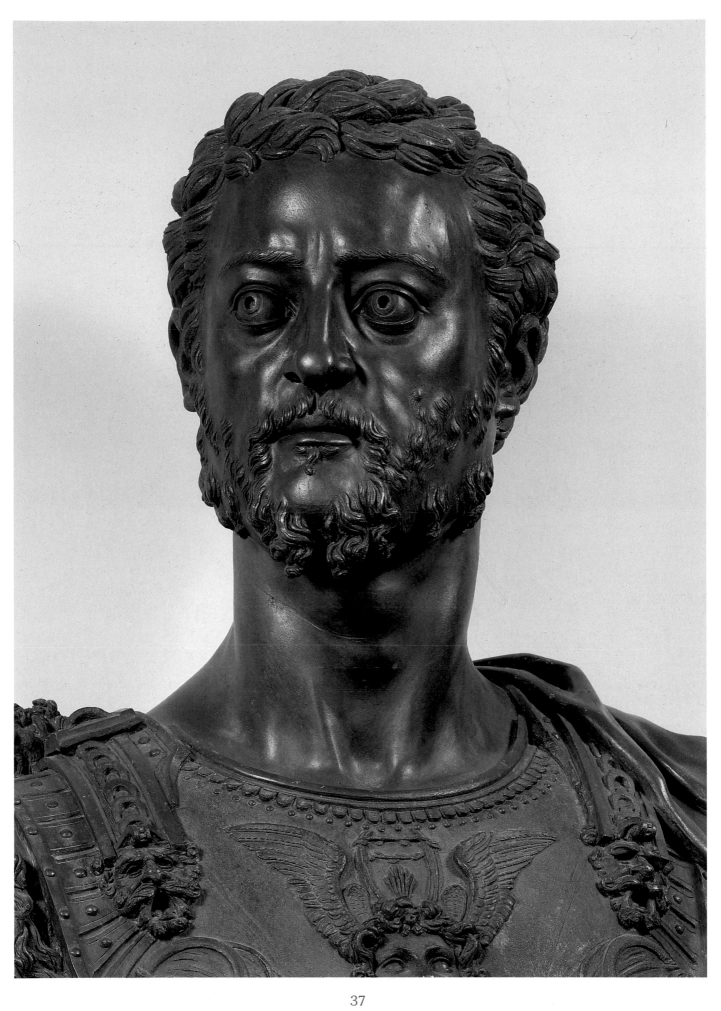

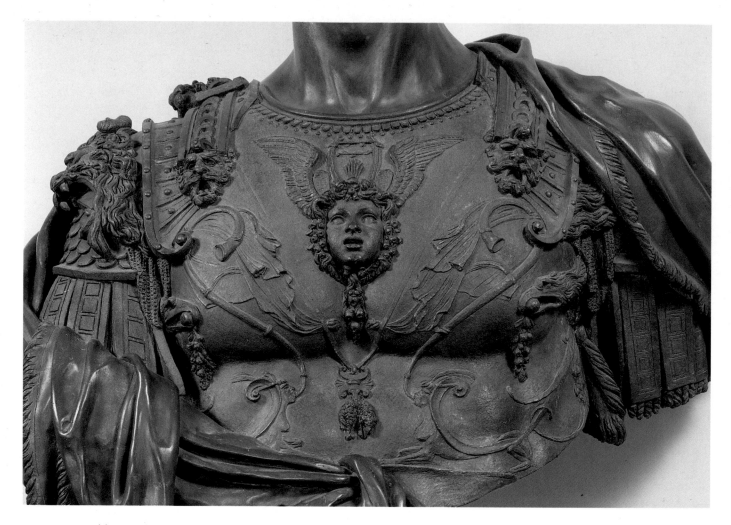

52, 53. Benvenuto Cellini
Bust of Cosimo I, detail of thorax and right
epaulette with leonine protome
Florence, Bargello Museum

penitence, like John the Baptist in Rustici's *Preaching to the Levite* that dated back a whole generation earlier; but rather a powerful homage to God's creative glory and the vital energy of the individual. Cellini's vision of the human figure was different to that of Michelangelo, despite that fact that he insisted on referring to the older artist as his master, though this was only true in so far as Michelangelo was the father of all modern art. So to create a monumental statue in full relief was a major undertaking for Cellini, one which was fired by great passion and absolute faith in his own abilities rather than any first hand experience.

"I gladly set to work on the model and in a few weeks I had finished it. It was about a cubit in height, in yellow wax, properly finished, and beautifully made with great care and skill" (p. 313).

The artist was speaking the truth, as the carefully preserved figure kept at the Bargello Museum clearly reveals.

With respect to the finished work, the wax statuette speaks for confident, accurate handling and a feeling for the dynamism and elasticity of the figure posed on his right leg, his raised hand holding aloft the severed head of the Medusa. It is a synthetic, stylized image, with elongated, tense muscles that respond to the impetuousness of the gesture. Despite the fact that the material has decayed, thus causing the model to curve slightly, it is easy to understand how so elegant

and sophisticated a creation must have enchanted the Duke, accustomed as he was to figures in which the turgid mass of muscles led in blocks from one plane to the next.

Cellini had produced something different. His model was sculpturally effective, yet it was also more essential in its deliberate, almost graphic simplicity. Just what it cost him to obtain such effects is something we cannot know, since he never hints at the real creative process in his writings. To the contrary, as often as not he tries to persuade us that those marvelous creations that so astounded his contemporaries involved very little in terms of calculated design.

Because of the paucity of original drawings and the loss of the other models, all we can find out about Cellini's method of operating must derive from the two models for the *Perseus*. We have already mentioned in the one in wax. Bearing in mind that it was the definitive one, there is actually little else that we can add. The Florentine stylistic influence is as evident as Cellini's familiarity with the work of the Fon-

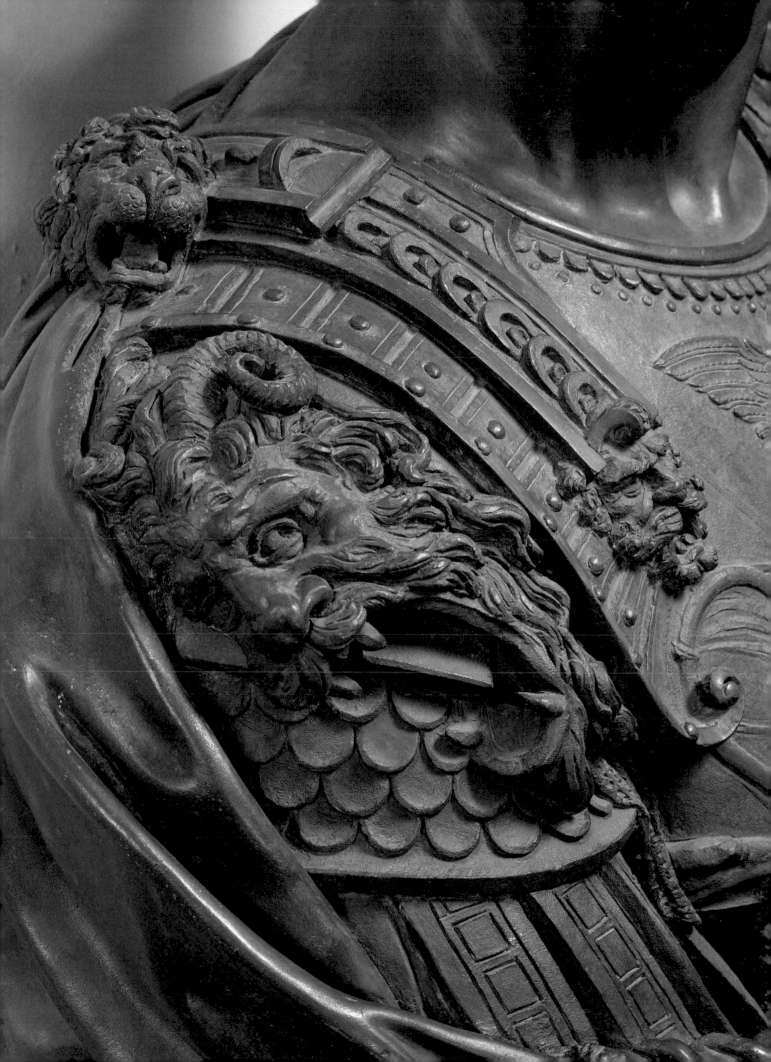

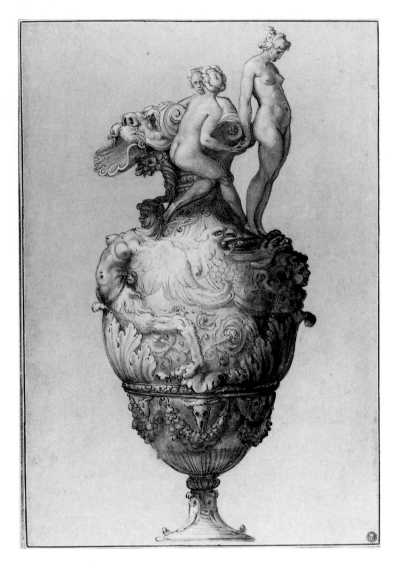

tainebleau School, to which he was clearly indebted. As for the bronze statuette of the *Perseus*, also at the Bargello Museum, we have evidence that it was originally conceived as table fountain, presumably with the wine coming out of the Medusa's severed neck, thanks to a hydraulic mechanism creating a permanent flow. This explains why the smaller bronze version of the figure in Piazza della Signoria was produced in the first place, and why it was so carefully finished, polished and burnished in every detail, including the hero's gilded boots. In fact in the larger-than-life final version of the work that latter feature is lost on the viewer. In his *Life* Cellini relates how his creation, once cast and cleaned up, was displayed to his fellow citizens during the last stages of the production process, before he had been able to finish the work with his fine chisels or varnish and gild the appropriate parts.

Clearly the artist reckoned on finishing the work so finely and in such minute detail that it would resemble the city's great fifteenth century bronzes. Recent restoration has revealed to latter-day eyes just how carefully decorated they were: Verrocchio's *Incredulity of Saint Thomas*, for instance, where the braid edging the garments still bears traces of the gilding that once highlighted the Kufic inscriptions.

One cannot help wondering whether the finished statue may not also have been presented to Cosimo as a large public fountain. It is a reasonable hypothesis, given the fact that the commemorative group that Cellini proposed to François I of Valois comprised a statue of Mars that embodied a fountain as well.

To return to Cellini's Florentine experience, the Duke saw the model and greatly encouraged the artist by declaring that the Perseus would be "the finest work on the piazza" (p.313). He thus believed that he "had cause for hope in the fact that the Duke had thrown away so many thousands of ducats on some abortive works of sculpture from the hand of that beast of a blockhead Bandinello" (p.315). In concrete terms, Cellini aspired to some financial return for his efforts, as well as gaining immortality and the esteem of his fellow citizens. Though Cellini believed that there was no one that could equal his work, he discovered to his dismay that in a city of artists, albeit of varying abilities, the salaries available were nowhere near those that he had enjoyed in France. Thus he soon found himself fighting to obtain a fee that was not lower than that of other sculptors. Once again, his point of reference was the wretched Bandinelli, to whom he was practically hostile on principle, since the older

40

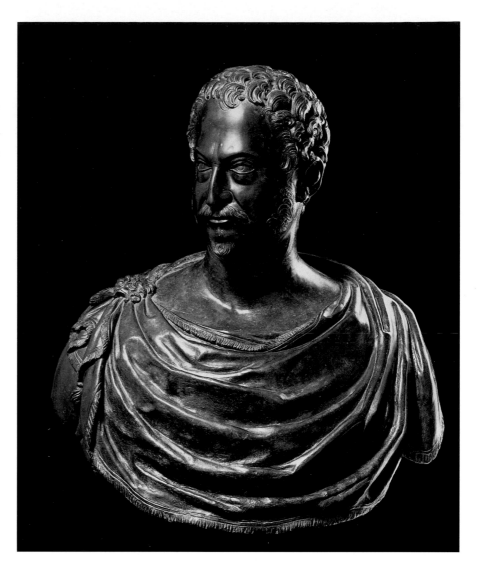

artist's different social position within the court could hardly have justified envy.

Cellini's short apprenticeship with the older Bandinelli, who was guilty of fathering Baccio, his later colleague and rival, must have been an unbearable experience, since he never fails to describe his shortcomings as a man and artist. At all events, Cellini managed to obtain two hundred crowns a year, which was not bad when one considers that the eclectic and much acclaimed Vasari only received three hundred. Once his salary had been arranged and he had found somewhere to live where he could also build his workshop, Cellini soon got down to work. In next to no time he had made a full-sized plaster model of the *Perseus*, using an apprentice lad, the son of a prostitute named Gambetta, as his model. He also asked to be allocated some of the workmen from the Opera del Duomo as his assistants, which gave Bandinelli the chance to suggest to the Duke that Cellini lacked the skill to make a great statue without help, especially since he had boasted that the finished work would be finer than the models he had presented.

"At the time my kidneys began to give me some pain and as I was unable to work I was only too glad to spend my time in the Duke's wardrobe, along with some young goldsmiths called Gianpagolo and Domenico Poggini. I got them to make a little gold vessel, decorated in low relief with figures and other beautiful adornments; this was for the Duchess and had been ordered by her Excellency for drinking water out of" (p.319). This and other remarks scattered here and there throughout the autobiography show how Cellini never abandoned the art of goldsmithery and chasing. Granted, he would have got the younger craftsmen to execute the basic models that he designed, concentrating his own efforts on the finishing touches that made them outstanding.

No trace remains of these works, and scholars after Plon have rarely tried to identify works of goldsmithery that even so much as echo the items modeled by Cellini. In our view, he must have spent considerable time at court working on such objects, since in Vasari's famous painting he is portrayed busy embossing a steel wheel with the devices of Cosimo and Francesco de' Medici at the behest of a charming Minerva. In any case this allegorical portrait is interesting on account of its reference to Cellini's lesser known activity as a steel embosser, as testified by the one item in this material that has come down to us.

Be all this as it may, on 15 February 1548, while

41

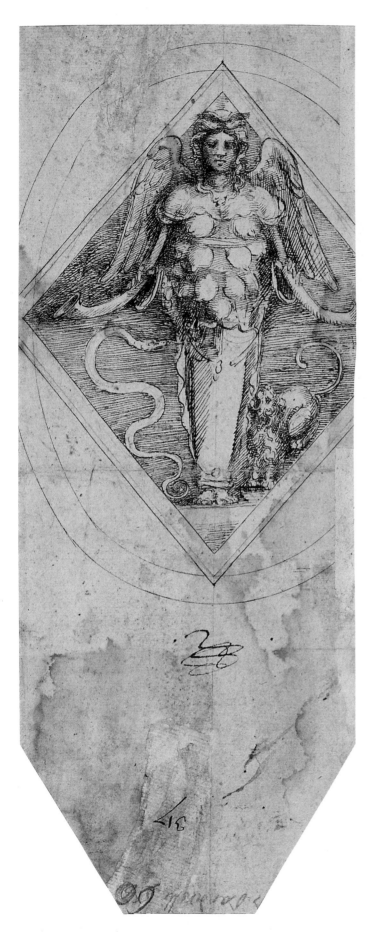

56. Benvenuto Cellini
Study for the seal for the Accademia del Disegno
cm. 30x12.5; Paris, Louvre

work was in progress on the bronze cast of the large bust of *Cosimo I*, now at the Bargello Museum, the Pogginis were busy chasing a gold vase that had been begun on 11 August 1545. Cellini describes it as follows: "... I made all the designs and models for it, and it was chased in half relief with two small figures in full relief and many other ornaments; I worked on it myself every day for a few hours" (Trento, p. 46).

The sculptural features of this work must have been fairly similar to those of the jug decorated with the Graces designed by Cecchino Salviati, now kept at the Ashmolean Museum in Oxford. However, we also have a detailed description of it thanks to the inventory drawn up at the death of Francesco I in 1587. In fact only one of the various gold receptacles mentioned appears to correspond with the one described by Cellini: "A solid gold vase after the antique with a Hercules handle and a putto on a garland, decorated around the body with three ovals containing low relief scenes and three more small ovals with figures, and around the neck with six chiseled figures with the Medici and Toledo devices; weight three pounds four ounces in a red leather case" (ASF, Guardaroba Medicea 126, c.11a). A vase of this sort would have measured about thirty centimeters in height and been shaped like a jug. This fits in with what Cellini says it was to be used for, thus suggesting a considerable undertaking whose many figures and scenes would have kept the artist busy for several years, especially given the fact that he was rarely able to devote long stretches of time to chasing. Yet it was certainly not the only item of goldsmithery that he executed during this period. In fact he also mentions a gold girdle worked with jewels and decorated with little masks that he made for Eleonora of Toledo, the Duke's wife. An idea of how these little masks must have looked can be obtained from the details of the armor in the antique style worn by the bronze bust of the Duke mentioned above, or from the larger than life-sized bust of Ottavio Farnese cast in bronze by Paolo Romano (1520-1584) that once belonged to the Cyril Humphris Collection (Sotheby's, New York 10-11/I/ 1995).

Though signed ·P·PAV·ROM·, this latter work would appear to be based on a model made by Cellini. In fact the pin that fastens the cloak at the shoulder features a grotesque face that seems to embody Cellini's manner of sculpting even if it lacks the refined chiseling that makes the fastenings of Cosimo's breastplate so astounding. Both reveal a confident yet almost turgid handling of form that is typical of artists more accustomed to obtaining the desired model by removing rather than adding matter. Goldsmiths in particular were wont to cut away at their chosen metal core until they achieved the forms they had in mind. Clearly the method was better suited to small works than to any kind of a monumental creation.

This is a stylistic observation that can be applied to much of Cellini's output, including the *Perseus*. In fact

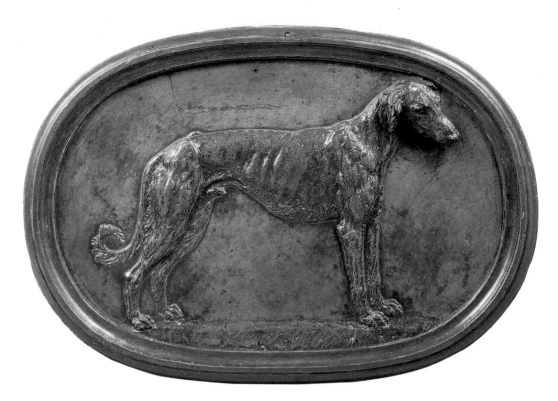

*57. Benvenuto Cellini
'Saluki' Greyhound
cm. 18x27.8
Florence, Bargello Museum*

swelling forms are a feature of all his certain works, from the *Perseus* itself to the bust of *Bindo Altoviti* in Detroit, which we shall be dealing with shortly.

Following his autobiography, we next come to a trip to Venice that he was practically forced to take, having been accused of sodomy out of pure envy. He makes special mention of the work of Jacopo Sansovino, whom he greatly admired and with whom he shared a passion for the same artists: Ghiberti and Michelangelo. The fact that Sansovino also recognized the latter artist as his master is evident in the works in metal he created in Venice, from the door at St Mark's to the bell-tower statues.

Cellini also relates how he met the Lord Prior of the Knights of Malta, Leone di Filippo Strozzi, the brother of the Pietro with whom he had been on good terms in France, when the latter was a General in the Army, and whom he was to continue to admire even when he became a declared enemy of Cosimo de' Medici during the long and bloody war against Siena.

Having obtained the Duke's pardon, Cellini returned to Florence, where "... the first work to be cast in bronze was that large bust of his Excellency that I had made in clay in the goldsmith's room, when I had those pains in my back. This was a very pleasing work, but my only reason for making it was to get experience of the clays for bronze-casting. I knew that the splendid Donatello had cast his works in bronze, and used clay from Florence, but I judged that he had only succeeded

with the greatest difficulty; and as I imagined this must have been because of a defect in the clay, before casting my Perseus I wanted to make these first experiments. By doing so I discovered that the clay was good, though the splendid Donatello had not understood it very well and his works had only been completed with great difficulty" (p. 326).

Cellini made various experiments to find out how best to use the materials nature had provided him with, including casting a small oval medal with the figure of a *Greyhound* that can still be admired at the Bargello Museum. The relief is only slight, projecting to different degrees according to the effects that the artist wished to achieve. Great skill must have been required in handling the Florentine clay for the purposes of such casts, and there is no doubt that what Cellini learnt from it would have stood him in good stead when it came to working on the base of the *Perseus*, where fine detailing was even more important than it was for the sculpturally more evolved figure of the Greek hero portrayed above.

Since his own furnace was still not ready, Cellini made use of that of the bell-founder Zanobi di Pagno and set to work on casting the Medusa. The outcome was so satisfactory that his friends thought he would be wrong to retouch it at all. "How to do this has been discovered by certain Germans and Frenchmen who maintain (and they claim some very fine secrets) that they can cast bronzes without retouching: a really fool-

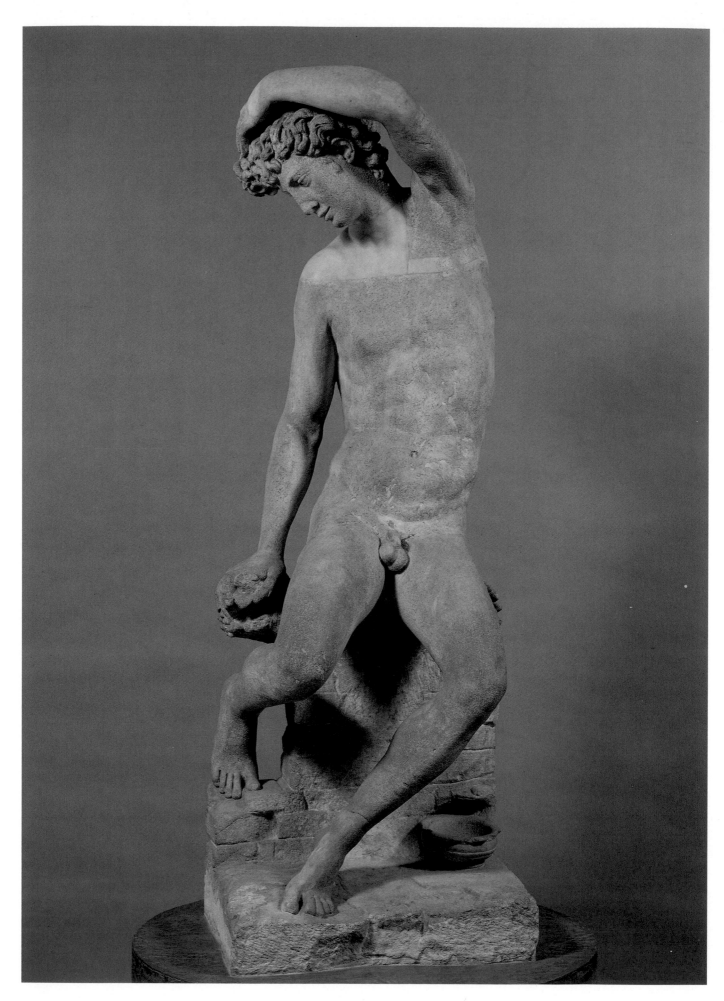

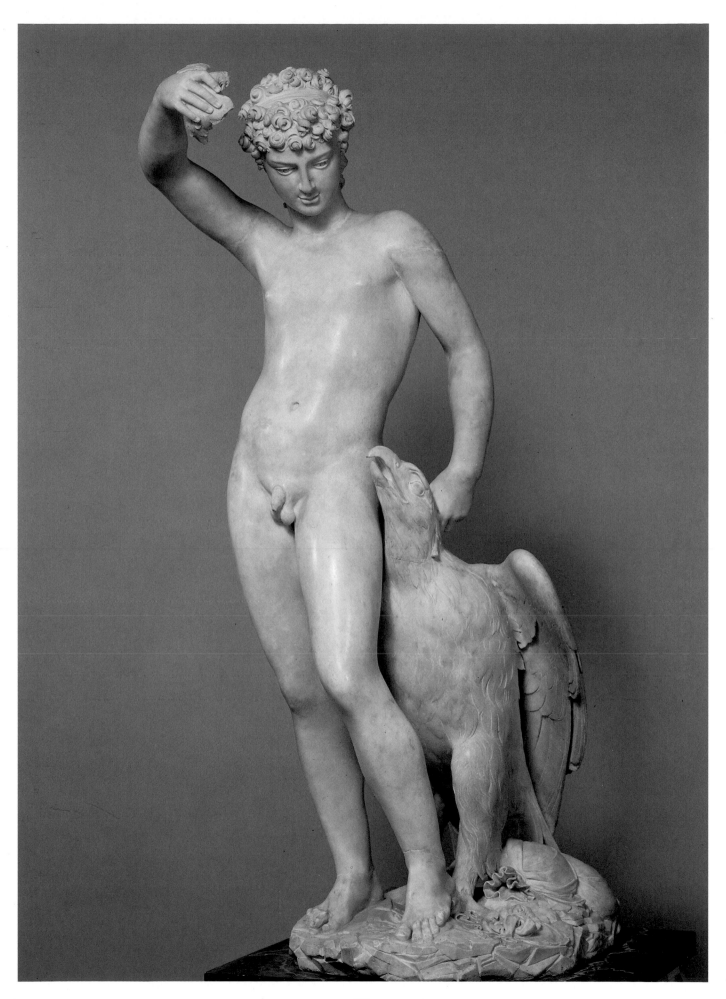

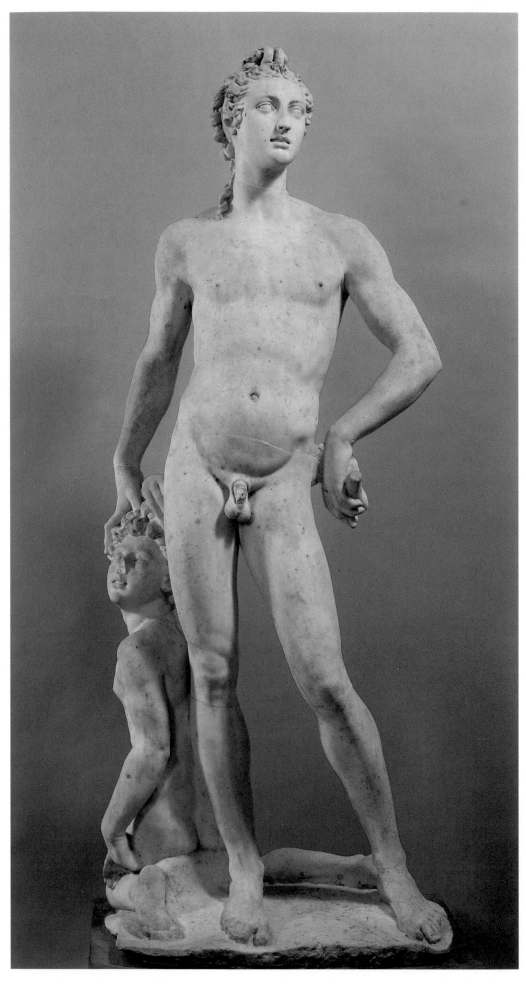

58. Benvenuto Cellini
Narcissus
cm. 149
Florence, Bargello
Museum

59. Benvenuto Cellini
Ganymede
cm. 105.5
Florence, Bargello
Museum

60,61. Benvenuto Cellini
Apollo and Hyacinth
cm. 191
Florence, Bargello
Museum

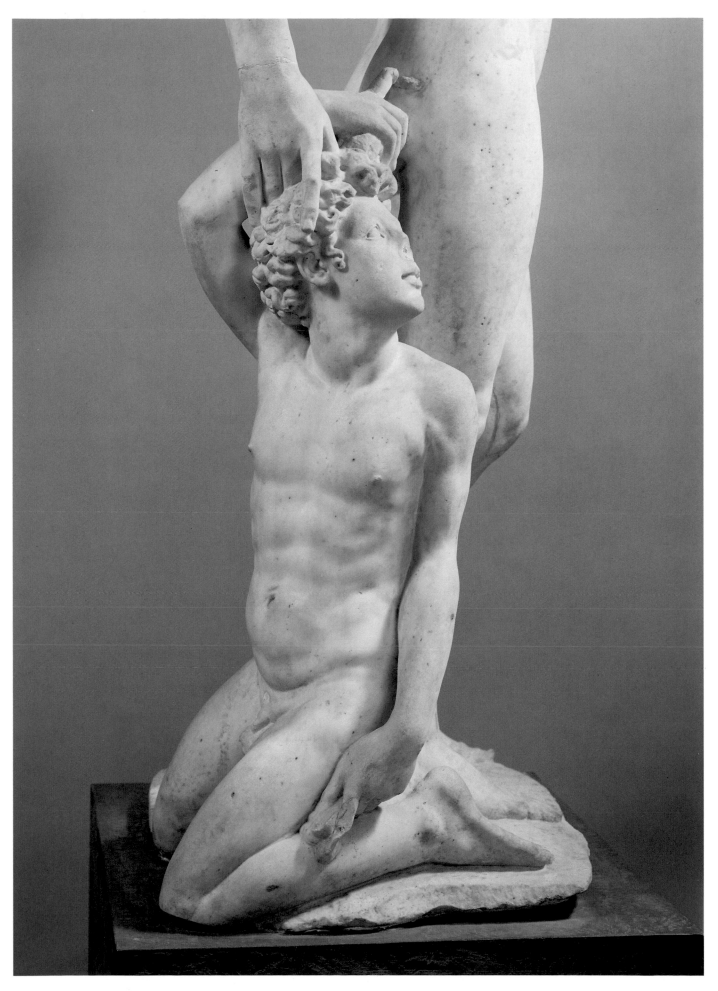

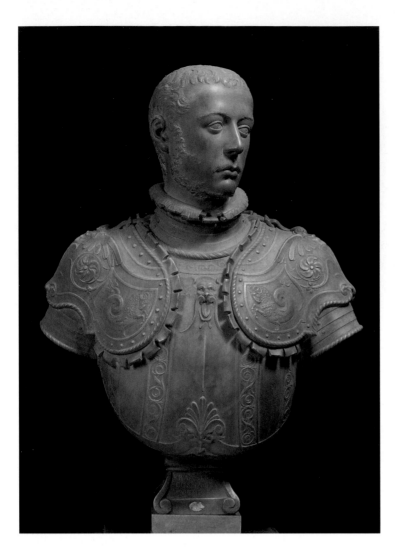

62. Domenico Poggini
Bust of Francesco I de' Medici
Florence, Uffizi Gallery

63-65. Benvenuto Cellini
Perseus
cm. 320 (bronze group); cm. 199 (marble base)
Florence, Loggia dei Lanzi (Piazza della Signoria)

ish claim, seeing that after bronze has been cast it must be worked on with hammers and chisels, as the most expert ancients used to do, and the moderns as well - or at least those moderns with any knowledge" (p. 327). This technical remark is particularly interesting, in that it reveals Cellini's antiquarian and archeological interests as well as the attention he paid to technique. For the treatises of the time, this manner of appraising and adopting other masters' techniques on the basis of their results was something new. Granted, Andrea Pisano and Ghiberti had both tried to gain information of this sort from a close analysis of what Bonanno Pisano had achieved for the doors of Pisa Cathedral. Yet Cellini expressed his opinions much more openly, thus revealing what was still a very rare attitude toward a work of art.

He expresses himself with great confidence, sure that the reader was perfectly able to understand why retouching the cast with a hammer and chisels was so necessary, as though such manual treatment obviously helped make the surface more continuous, easier to gild and glaze, and also stronger. In fact the founders of the Ducal artillery who had been specially summoned from Germany were well aware of what Cellini was saying: they always treated their products in this way so that the barrels were better able to stand up to the impetus of gunpowder. Yet the faithful Cellini may also have insisted on this point so that his patron would realize just how important it was for the durability of both statues and artillery.

Returning to his work as a goldsmith, Cellini relates how he was commissioned by Cosimo to make what must have been a very large silver vase. Cellini gave the work, along with his designs and a little wax model, to another goldsmith, who made such a bad job of it that in the end he had to give up. The Duke got to hear of this and had the vase and models taken away and sent to Venice, where they were just as badly executed. Cellini makes it quite clear that he no longer dealt with silver work himself, but instead entrusted the execution to others. This would also have been the case with the little vases "about the size of a cheap pot, and ornamented with beautiful masks in very unusual style, after the antique" (p. 332) that he made for the Duchess, thinking he should keep in her good books. Although she was not hostile toward the artist, she found it extremely irritating when he contradicted her. Cellini could not conceive of his work as a mere carrying out of his patrons' orders, so that his manner must often have seemed brusque and irreverent. Yet the daughter of the Viceroy of Naples must have been proud of what he achieved and the fact that he pre-

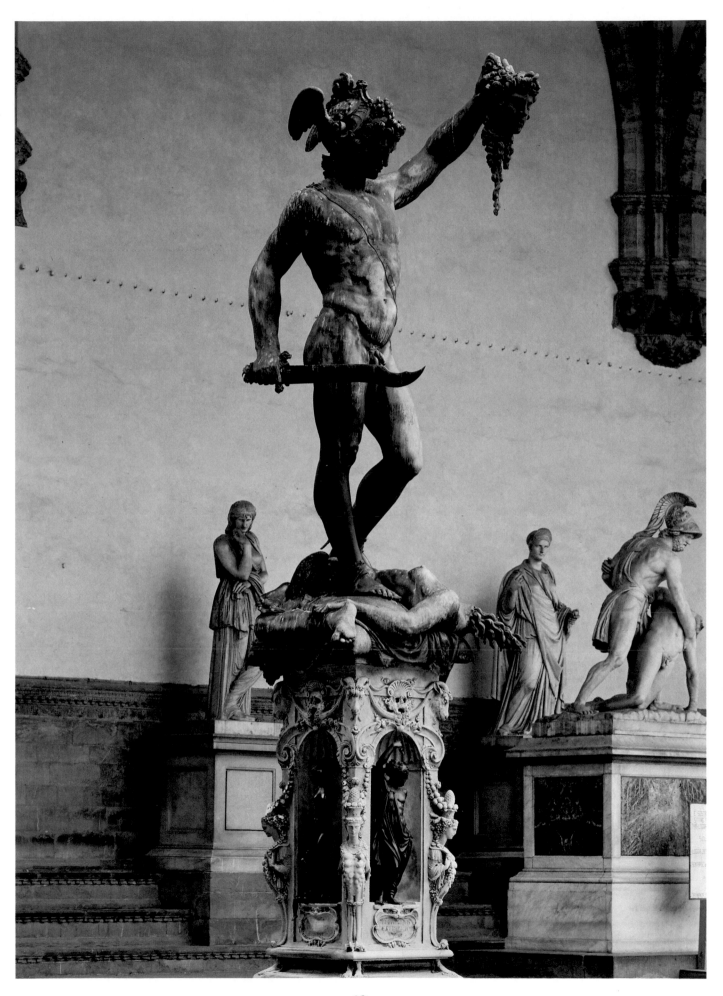

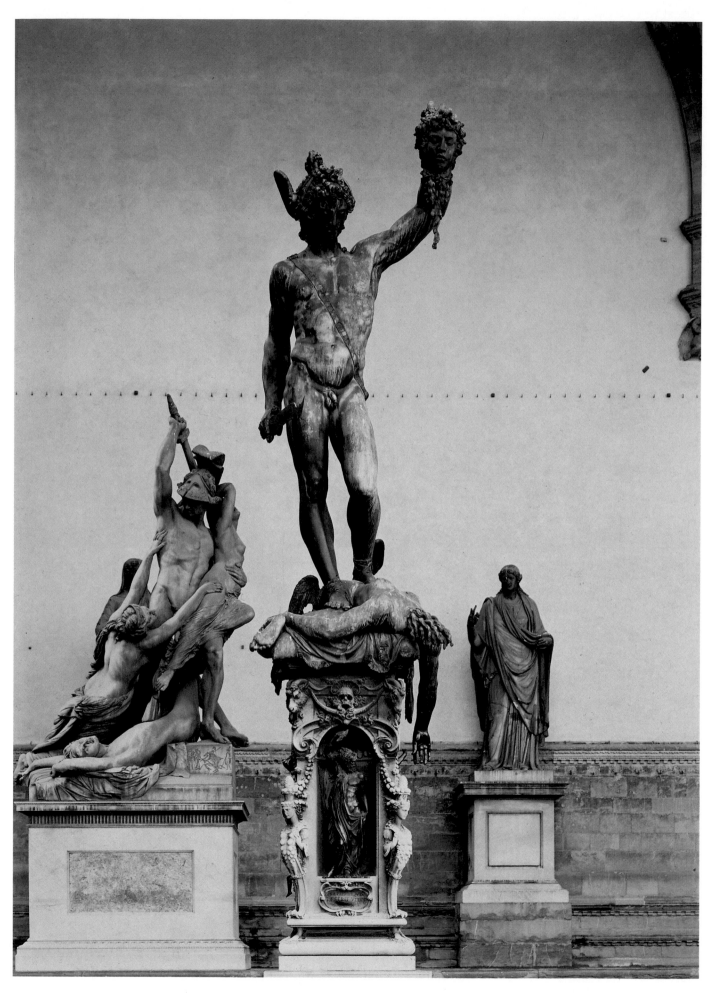

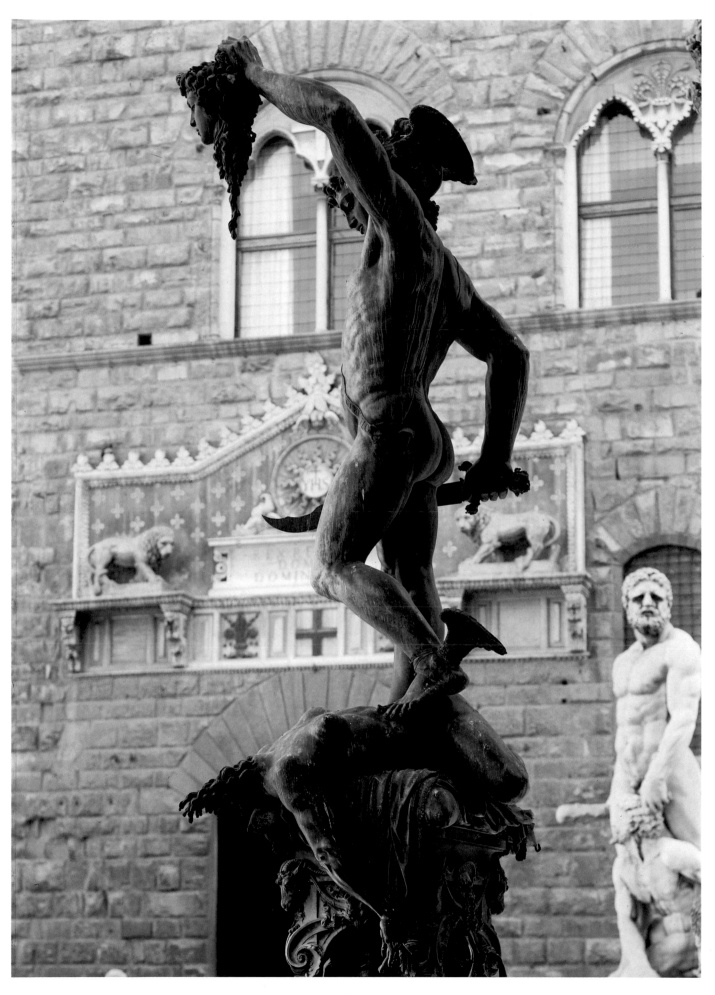

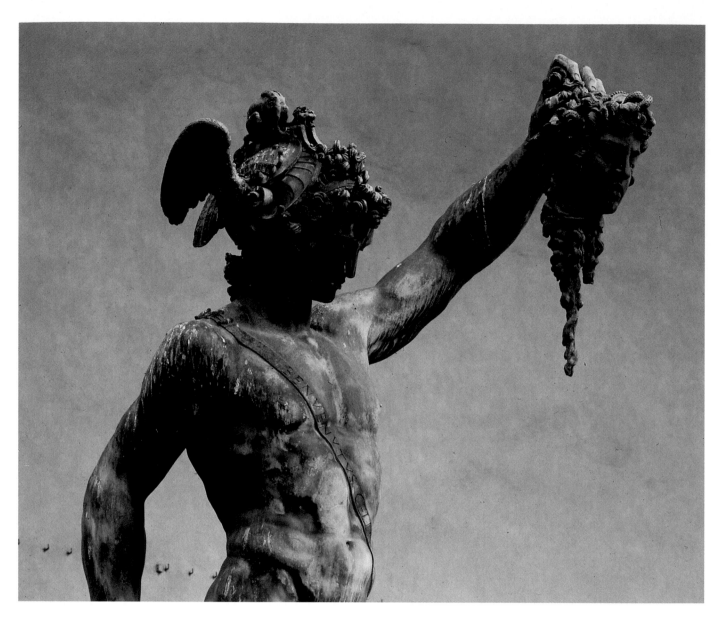

66, 67. Benvenuto Cellini
Perseus, details
Florence, Loggia dei Lanzi (Piazza della Signoria)

ferred the Florence court to that of the King of France. Certainly it is no coincidence that Cellini should relate how she asked him to set a diamond for her which she then sent as a gift to King Philip II of Spain (1527-1598): "The ring was for her little finger, and so I fashioned four little cherubs in relief and four little masks, to form the ring. I also fashioned some enamel fruits and links so that together the jewel and the ring made a beautiful show..." (p. 334).

It was at this time that Stefano Colonna, Prince of Palestrina († 1548), sent Cosimo a little chest containing an antique torso that Cellini greatly admired. Anxious to please him, the Duke entrusted him with the task of restoring it. This was a chance for proving himself beside an artist of antiquity, and Cellini accepted the challenge with enthusiasm. The outcome was the *Ganymede* at the Bargello Museum: an entirely new interpretation of the subject that did not follow Michelangelo's iconography with the figure astride the eagle, as engraved in a gemstone by Giovanni de' Bernardi. Cellini used Greek marble, which Cosimo I had ordered specially, and since the

block was fairly large he managed to get a *Narcissus* out of it as well. Though now also kept at the Bargello Museum, this work suffered considerable damage during the long time it was kept out in the open in the Boboli Gardens. "As there were in the marble two holes, more than a quarter of a cubit deep and a good two fingers wide, I gave my statue the attitude that can be seen, so as to avoid the holes and cut them out of the figure. But for tens of years the marble had been exposed to rain, and with the holes always full of water the rain had penetrated so deeply that the block was decayed; and how rotten the top hole was proved later on, when the Arno was in flood and the water rose more than a cubit and a half in my shop. The Narcissus was on a wooden block, and as a result the water toppled it over and it broke across the breasts. I pieced it together, and in order to disguise the crack I

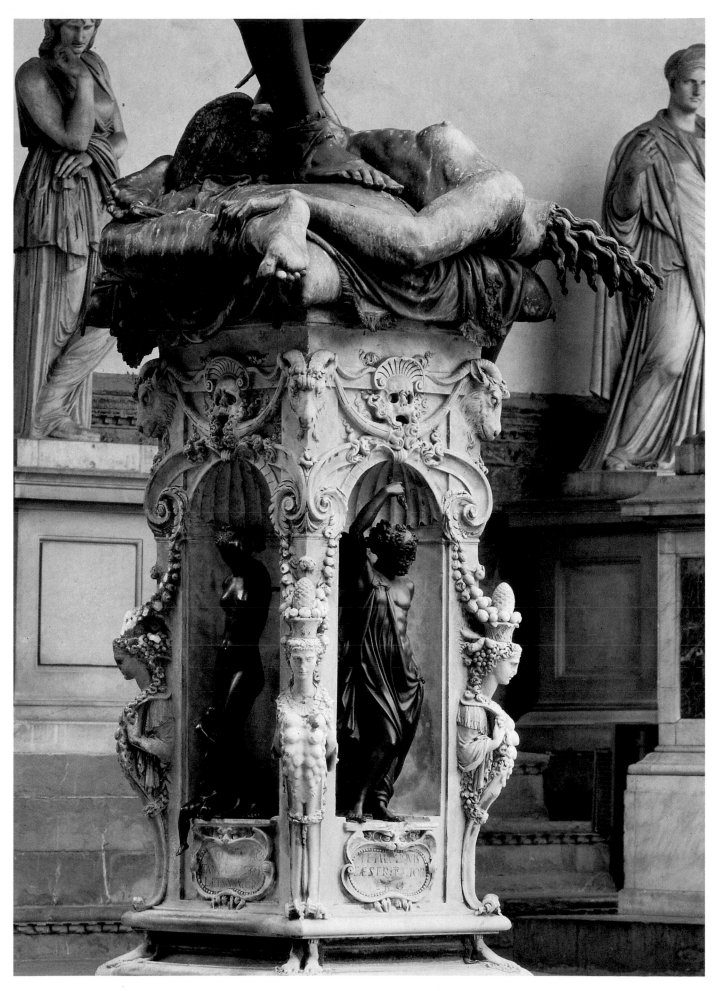

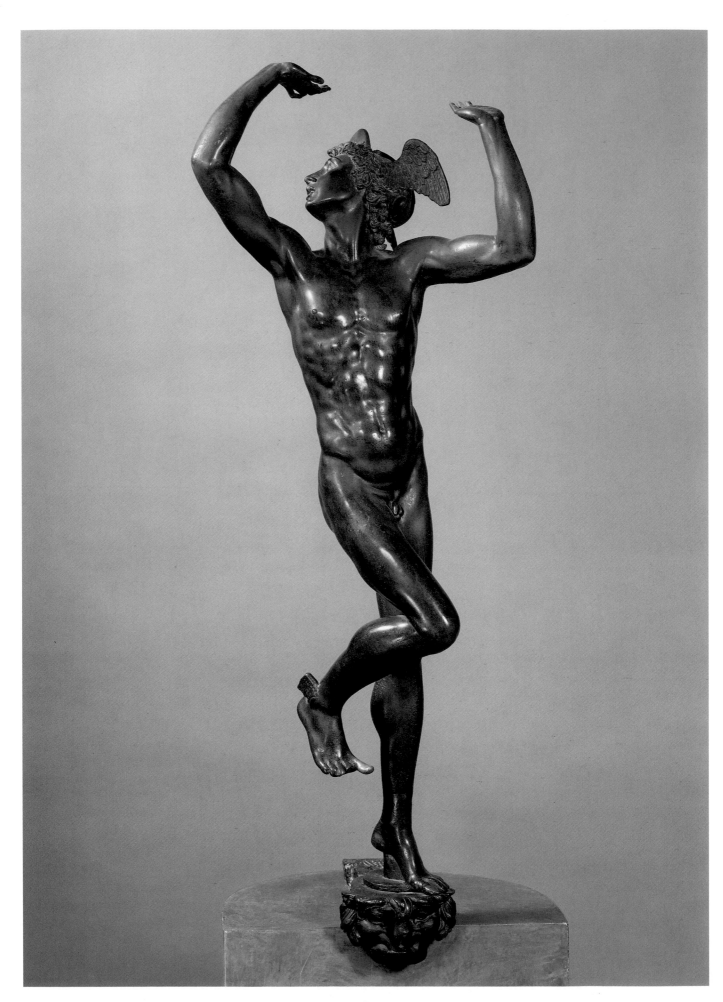

54

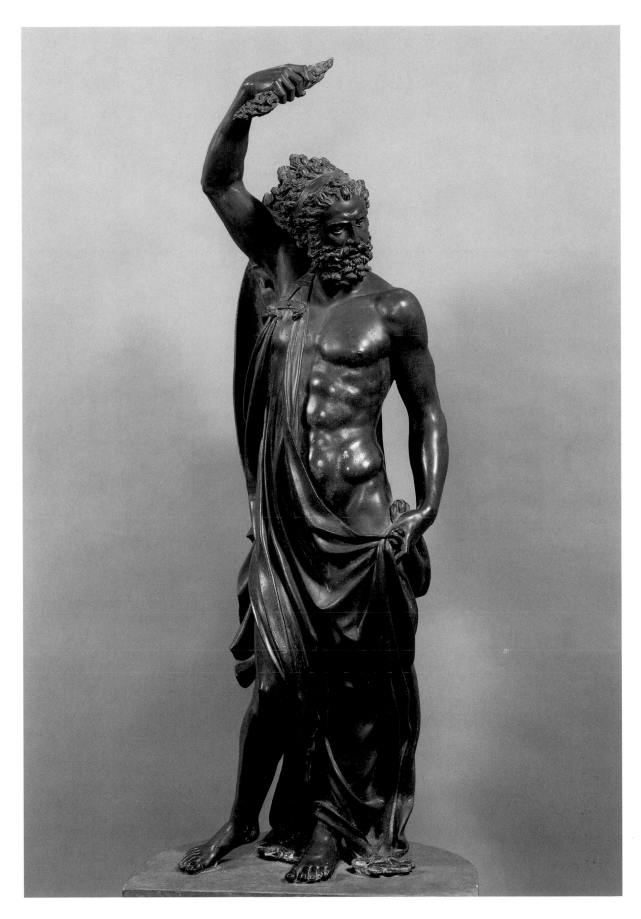

68. *Benvenuto Cellini*
Mercury
cm. 96
Florence, Bargello Museum

69. *Benvenuto Cellini*
Jupiter
cm. 98
Florence, Bargello Museum

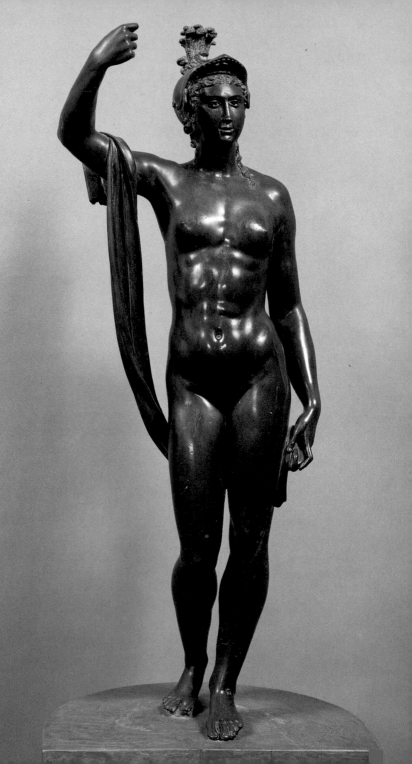

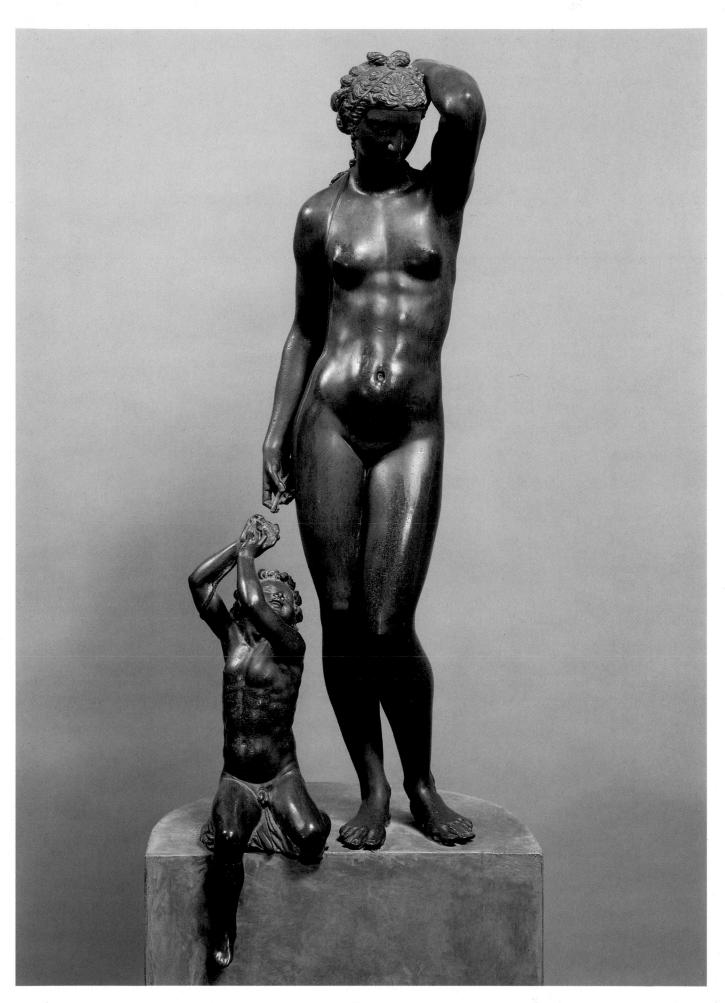

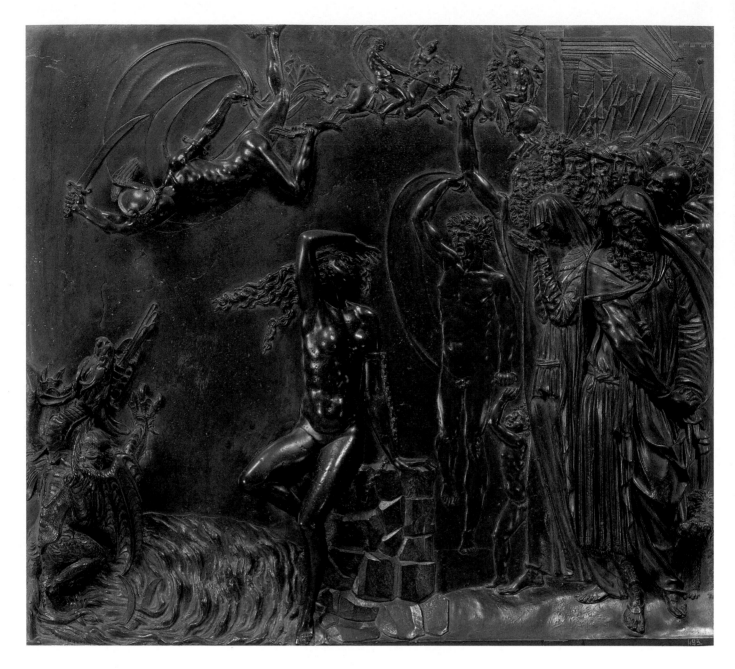

added the garland of flowers which can be seen on its chest..." (p. 340).

It was also in this period that Cellini received another block of marble, a smaller one that Bandinelli had promised him earlier, perhaps more in the hope of patching things up with his father's former pupil than with the aim of mocking him, as Cellini seems to suggest. In fact since Cellini refused to pay for having the block transported from the Opera del Duomo to his own workshop, in the end the Duke stepped in, tired of the endless quarrels that blew up over any trifle. Cellini set to work on it with such furious impatience that he failed to make the necessary models. The result was the standing figures of *Apollo and Hyacinth*, a somewhat banal, frontal composition which appears to bear no trace of Michelangelo's teachings. It remained unfinished in Cellini's workshop, and when he died it passed with all his belongings into the hands of Francesco I, and thence to the Bargello

70. *Benvenuto Cellini*
Minerva
cm. 89
Florence, Bargello Museum

71. *Benvenuto Cellini*
Danae and her Son Perseus
cm. 84
Florence, Bargello Museum

72, 73. *Benvenuto Cellini*
The Rescue of Andromeda
cm. 82x90
Florence, Bargello Museum

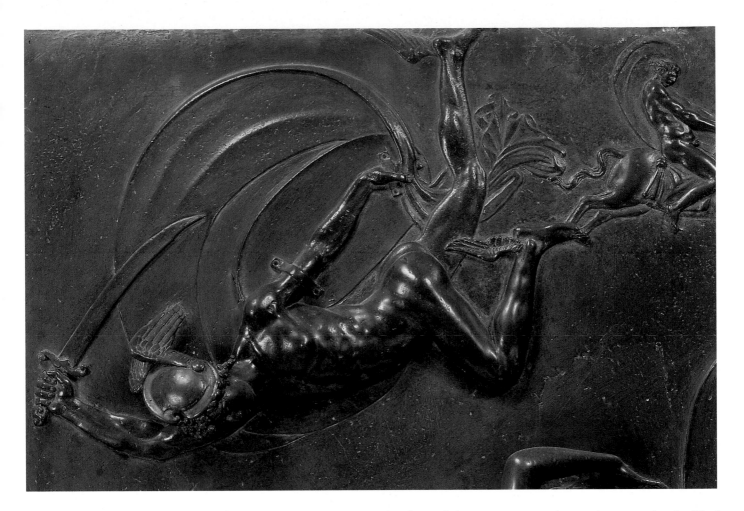

Museum, where it is still to be found to this day.

These are the earliest works in stone by Cellini to have come down to us. We do not know for sure whether or not he executed or supervised the execution of the marble bust of Cosimo now at the Fine Arts Museum of San Francisco. Although it in every way resembles the bust at the Bargello, the marble version lacks the concise solidity of detail of Cellini's own work and instead recalls that of Poggini, especially the portrait of *Francesco I de' Medici* at the top of the Uffizi stairway. At all events Cellini does not appear to be entirely at ease when it comes to sculpting stone, not least because he was not fully familiar with the material. Yet he did his best and actually handled the definition of the hair with great subtlety, even though his previous experience as a goldsmith almost ineluctably shows through in the somewhat metallic precision of the curls.

When the definitive wax model of the *Perseus* was finally ready there were more arguments with Cosimo, who simply could not believe that an object of that size could be successfully cast, given the tendency of the metal to cool down and become solid, leaving large gaps. Cellini reassured his patron, perhaps a little curtly, explaining how there was no risk of the Medusa's severed head not coming out well because the model would be upright, and not upside-down, as the Duke imagined. He nevertheless admitted that casting something so big would be difficult and that

the foot of the *Perseus* might not be completely filled by the bronze.

The pages the artist devotes to describing his preparations, the choice of wood for the furnace, the casting process and his improvised solution for counteracting the coagulation of the molten metal by throwing in his tin tableware have practically become legendary. His detailed, concise account illustrates all stages of the undertaking, emphasizing the incompetence of his bungling collaborators, his own feverish state brought on by the fatigue that almost did him in physically and finally his brilliant way of making the alloy melt again. At the cost of nearly burning the house down, he managed to make the mold fill up perfectly with molten metal.

Although chemical and physical analyses of the *Perseus* have shown that Cellini tends to exaggerate in his tale, since no trace has been found of the sixty pounds of tin that he claims to have added to the alloy, stirring it with pokers and risking his very life, there is no doubt that the artist knew very well how to make the metal melt. "...I found that the metal had all curdled, had caked as they say... I ordered ... a load of young oak... because it burns much more fiercely than any other kind of wood, and so alder or pinewood, which are slower burning, is generally preferred for work such as casting artillery. Then, when it was licked by those terrible flames, you should have seen how that curdled metal began to glow and sparkle" (p. 346).

It is not surprising that Cellini should have wanted to make his account more dramatic, and certain technical details that cannot actually be proven may in fact be substantially true. Indeed, those sixty pounds of tin and the tableware may never have amalgamated with the alloy but rather evaporated on contact, thereby helping it to flow into the mouths of the mold.

"I left the case to cool off for two days and then, very, very slowly, I began to uncover it... I reached the foot of the right leg on which it rests. There I discovered that the heel was perfectly formed, and continuing farther I found it all complete: on the one hand, I rejoiced very much, but on the other I was half disgruntled if only because I had told the Duke that it could not come out. But then on finishing the uncovering I found that the toes of the foot had not come out: and not only the toes, because there was missing a small part above the toes as well, so that just under a half was missing. Although this meant a little more work I was very glad of it, merely because I could show the Duke that I knew my business. Although much more of the foot had come out than I had expected, the reason for this was that - with all that had taken place - the metal had been hotter than it should have been, and at the same time I had had to help it out with the alloy in the way I described, and with those

60

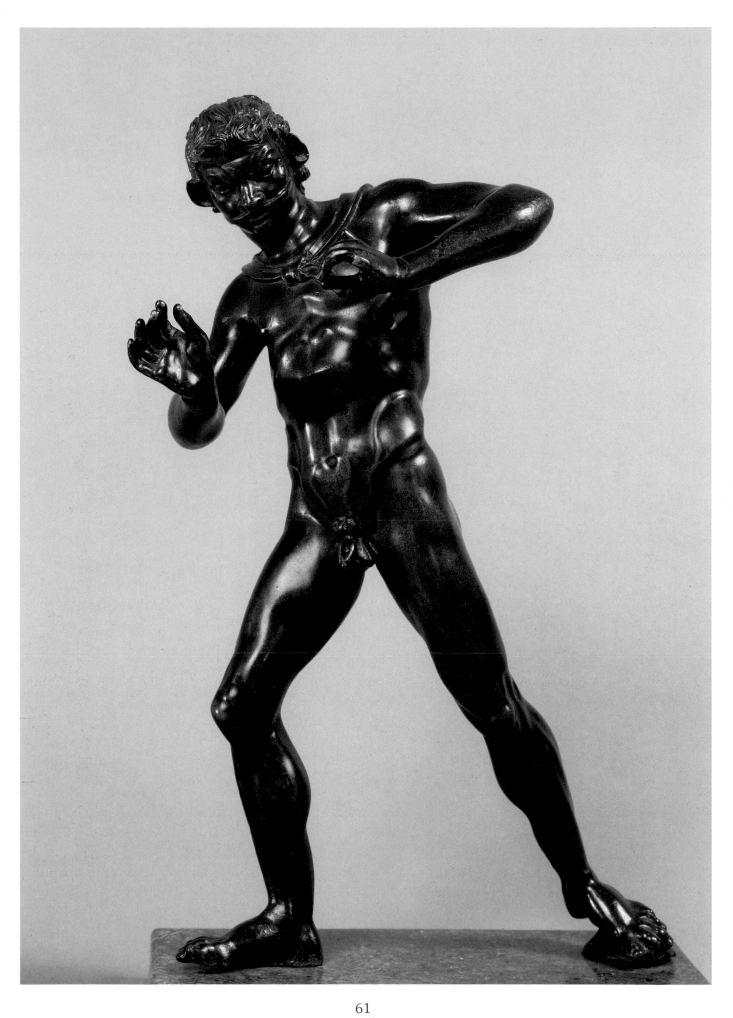

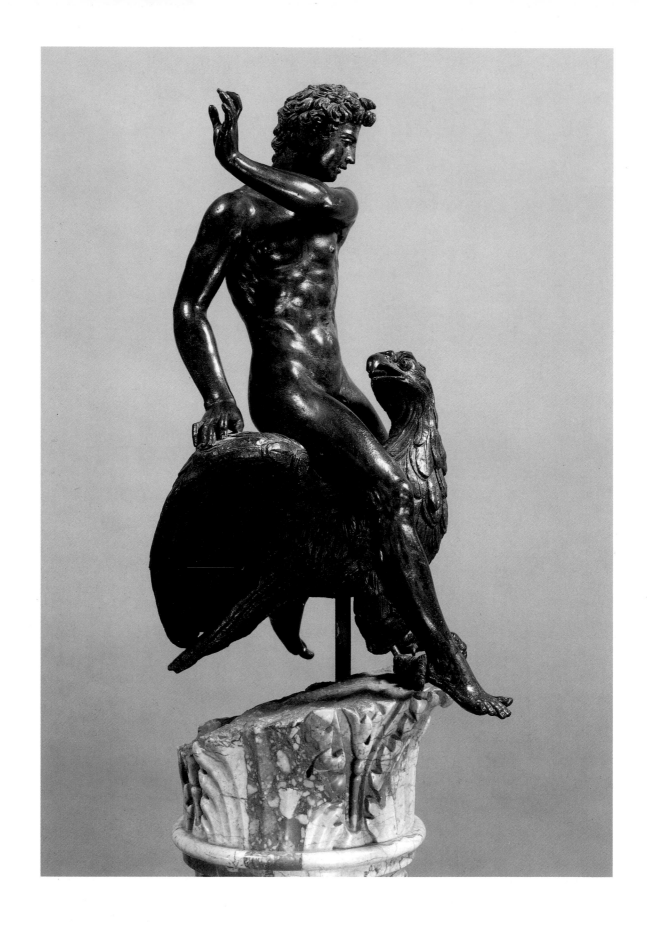

76, 77. Benvenuto Cellini
Ganymede
cm. 60
Florence, Bargello Museum

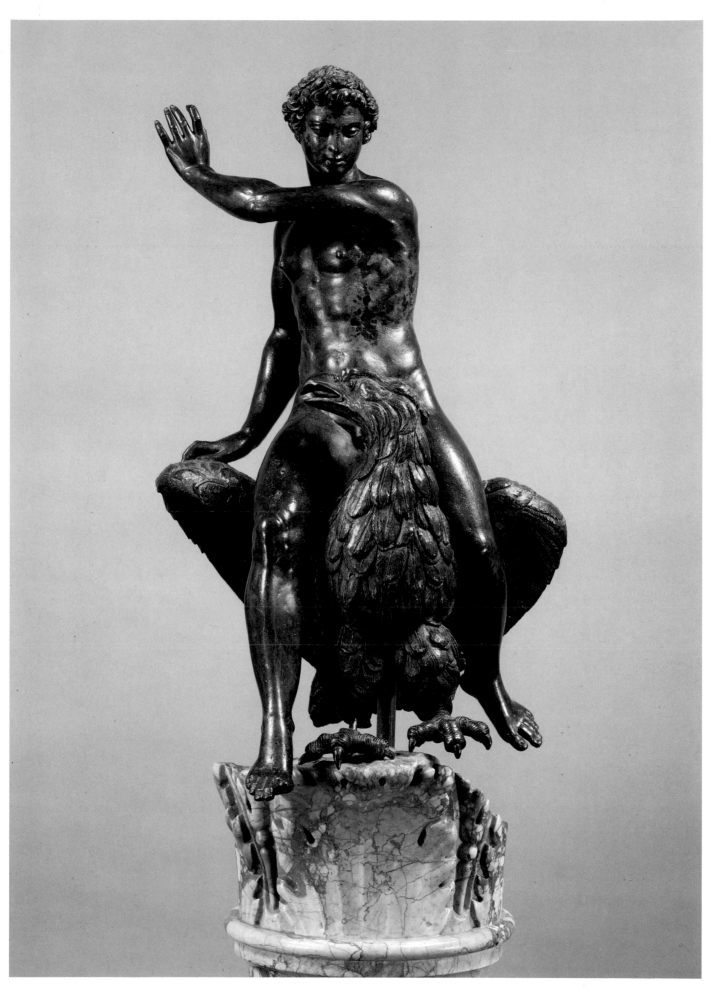

63

78. Benvenuto Cellini or Domenico Poggini
Medal of Bindo Altoviti, obverse side
cm 4.2
Florence, Bargello Museum

79. Benvenuto Cellini or Domenico Poggini
Medal of Bindo Altoviti with Female Figure, reverse
side
Florence, Bargello Museum

tin vessels - something no one else had ever done before" (pp. 348-349).

This is the explanation that Cellini adopts for himself and his readers to show how skillful he had been in casting a larger than usual bronze figure. He thus recognizes his own merit in having fully understood and indeed almost transcended the limits of the technical possibilities available to metal workers at the time. Although modern readers may find it hard to grasp the importance of this passage, it is worth making the effort in order to appreciate just what Cellini achieved in his work.

Technological progress has provided the modern age with different fuels and the construction of blast furnaces in which staggeringly large crucibles make it possible to reach extremely high temperatures in which even solid steel can be melted. All this was still to come in Cellini's day, when the idea of cast iron was practically unthinkable, even though ferrous materials had been used for smelting in artillery production since medieval times. However, as far ahead as the entire Napoleonic period, the fire arms that thundered away on the battlefields were all made of shiny bronze. This certainly says something for the difficulties encountered in casting even small objects in ferrous materials. Yet bronze itself was no easy matter. When molten it would flow into the molds drawn by the force of gravity alone, and although the molds used to be covered with earth to reduce heat dispersion, they nevertheless tended to cool the molten bronze down as it flowed into the hollow extremities. The larger the statue to be cast, the more difficult the operation, and the

more complex and intricate the model, the greater the likelihood of failure. All this helps explain the form of the *Perseus* and the reason why Cellini was practically forced to cast the figure of the Medusa draped around the cushion beneath the hero's foot separately.

Stylistically speaking, the composition of the *Perseus* is usually related to that of Donatello's *Judith*. However, in this latter case the technical problems were resolved differently, and anyway the artist's chances of success were greater because the statue was much smaller. As for the fact that in the final cast Cellini gave his hero shorter boots than he did in the wax and bronze models, this is probably at least partly due to his desire to have a smooth, continuous surface to work on in case he needed to repair any casting faults. It goes without saying that, having chosen to portray Perseus not in the usual Donatellian pose with the hero striking the Medusa, Cellini could never have cast the large knife he holds in his right hand because it would have required numerous small channels for the molten metal flowing in from the body of the statue and just as many air vents.

Cellini's fellow citizens were not wont to pay idle compliments, and the praise that he received when he uncovered the statue that day in April 1554 and displayed the finished product to public viewing was certainly also due to the remarkable technical skill that it embodied. In a city full of talented artists, expressions of such warm admiration were rare indeed. For Florence, as Cellini himself declared, was considered an "Academy", a new Athens of art and learning. The

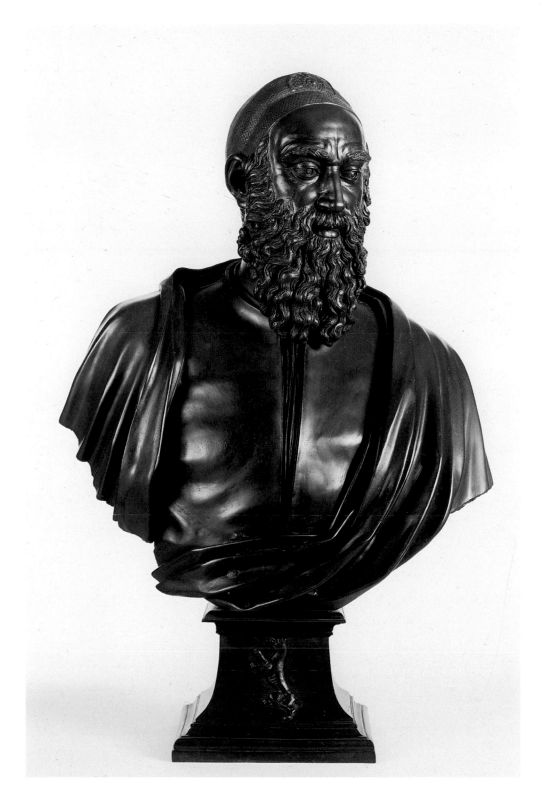

80. Benvenuto Cellini
Bust of Bindo Altoviti
cm. 105.5
Boston, Isabella Stewart Gardner Museum

Florentines were so used to seeing anatomically correct portrayals of the human body and ingenious compositions that another statue, however well made, was not normally worth talking about. Bandinelli was well aware of this: he had produced many good statues, such as *Adam and Eve* for the Cathedral Chancel; yet the wretched *Hercules* that adorned the corner of Palazzo Vecchio and was supposed to represent the Duke's power had attracted a stream of derisory verse.

In his *Life* Cellini tells how the Duke insisted on

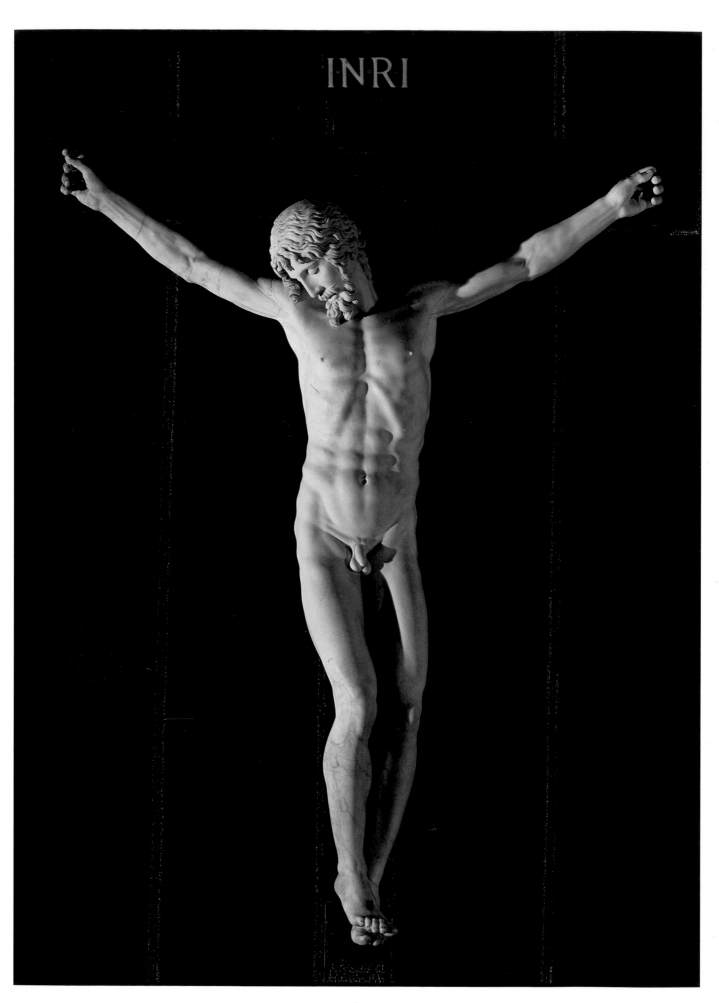

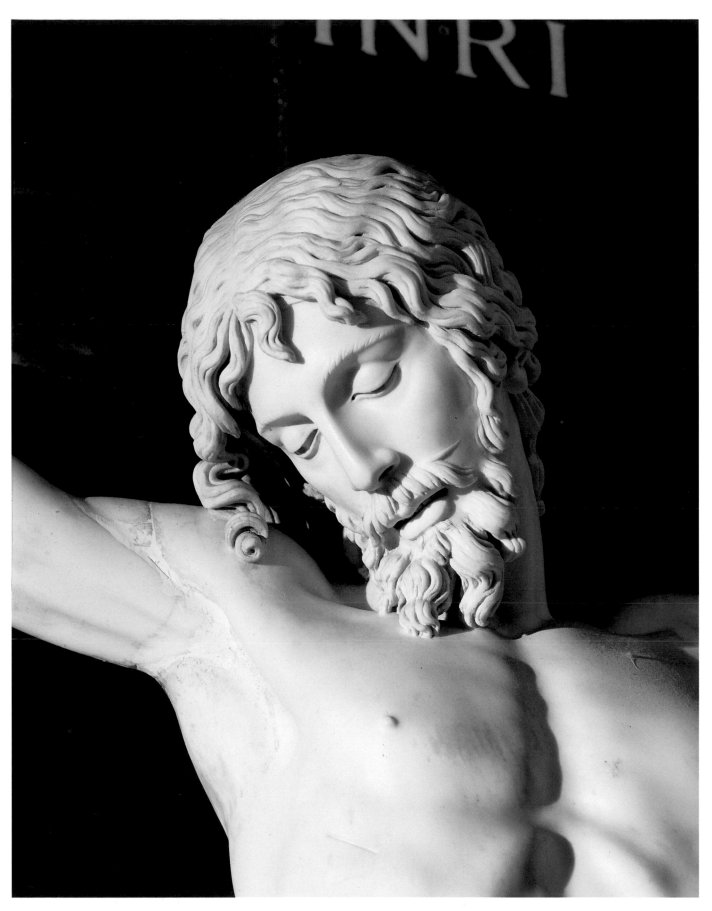

81, 82. Benvenuto Cellini
Crucifix
cm. 185
Escorial, Monastery of San Lorenzo el Real

him working for some time just after the successful casting of the *Perseus* with his workshop doors open, as if to show the Florentines what he, Cosimo de' Medici, had been able to give the city in terms of art and patronage. While the sonnets of praise attached to the door posts undoubtedly gratified the artist, the fact that the statue dominated the Loggia of the Signoria must have been a source of great satisfaction for Cosimo. There were various reasons for this: first and foremost, the beauty of the new creation helped forget the shame of Bandinelli's *Hercules and Cacus*, even though Cosimo was not really responsible for it; and secondly, the *Perseus* allowed the Duke to make a public display of what was a deliberately symbolic figure of evident political significance. Initially there was Donatello's *Judith* which used the Old Testament character to allude to the Republican virtues of freedom; this was later flanked and superseded in allusive value by Michelangelo's *David*; finally with the *Perseus*

Florentine citizens had a symbol of the mythical individual hero of semi-divine origins, related to the cult of classical renaissance. Just as the Caesarism of the sixteenth century tended to present the DUX ETRURIAE, so this new figure could outweigh the monuments of the Republican age.

There is no doubt that as a vehicle of political propaganda, the *Perseus* was one of the most successful "cultural" operations of the new Dukedom, not least because it coincided with Florence's war with Siena. Although for many citizens this may have seemed little more than a continuation of the endless regional feuds that had been waged since medieval times, for the Empire the armed struggle constituted urgent and in some respects essential peninsular "police" action. The enemy city was backed by the French, whose militia in Tuscany was led by the Strozzi brothers whom Cellini had got to know at the court of François I and visited in Venice. In fact Cellini was not interested in

83, 84. Benvenuto Cellini and assistants
Morion for Francesco di Cosimo I de' Medici
cm. 37
Dresden, Staatliche Kunstsammlungen

the political side of what he had created and took no side in the matter. In this he differed from Michelangelo, who continued to make his point by refusing all invitations to return to his native city. The only thing that interested Cellini was showing his skill in producing beautiful forms to express his client's concepts, no matter who and what they were. In this sense he failed to achieve the stature of others of his contemporaries and only really left his mark within the sphere of art.

Pleased with what he had achieved, Cellini begged the Duke's permission to go to Rome: "The reason for my going was this. I had done a bronze bust of Bindo d'Antonio Altoviti, life-size, and had sent it to

him in Rome, where he put it in his study, which was beautifully furnished with antiques and other fine objects" (p. 349).

Cellini was not paid by his client for this bust, now at the Isabella Stewart Gardner Museum in Boston, because as an opponent of Cosimo's government Altoviti had had his Florentine belongings confiscated during the war with Siena. Cellini actually managed to get the Duke to pay for it, obtaining on 21 November 1555 a signed promissory note for one thousand two hundred crowns, the sum originally established for the bronze (Florence State Archive, Depositeria Generale Antica n. 952). Cellini claims that Michelangelo greatly appreciated the work, which certainly gives us a good idea of how he operated at the time and what kind of esthetic goals he pursued in his minor engagements. Yet it is still difficult, for example, to distinguish the parts he restored in the small Etruscan and Roman bronzes found at Arezzo during the exca-

vations that preceded the construction of the new fortifications. There is no doubt that the earliest item found there was the *Chimera*, now at the Museo Archeologico. However, Cellini never mentions doing anything to it. What he does relate in an anecdotal way is the time he used to spend in Cosimo's private quarters in the evenings, when the Duke amused himself by cleaning up the antique bronze statuettes with a goldsmith's chisels, letting Cellini restore the missing parts. It has been suggested that Cellini may have been responsible for the little rearing horse supporting a figurine of Alexander known as the *Herd of Alexander*, also at the Museo Archeologico in Florence (inv. 35). This item once belonged to the famous and no longer extant group showing Alexander leading his horsemen. The repair job would certainly not have been the first of its kind, since we have evidence of Cellini dealing with restoration of this sort from the year 1548. Nor would it have been the last. In fact scholars have recently gained a much clearer idea of how Cellini's middle-sized bronze, *the Nude of Fear* at the Bargello Museum (inv. Bronzi n. 88), came about. It was an almost academic exercise, derived from a classical prototype that was repeated in various editions by different Renaissance artists.

The highly polished surface of this latter piece and the original pale reddish patina that closely resembles that of the *Altoviti Bust* could suggest that the famous *Ganymede* at the Bargello Museum is also by Cellini. In fact although he does not mention it in his autobiography, the work has often been attributed to him on account of certain of its formal features. Given the fact that Cellini's *Life* ends with the year 1562 and that there is therefore no mention of certain works that could well be by him, it seems reasonable to recognize his manner in the emphatic handling of the tight curls of the young cup-bearer of the gods, whose slightly faltering slim body recalls that of the bronze statues at the base of the *Perseus*.

A comparison of the bronze *Ganymede* and the *Mercury*, now kept along with the *Jupiter*, the *Danae with the Young Perseus* and the *Minerva* at the Bargello Museum, seems to corroborate Supino's original attribution. Moreover, there are no more convincing hypotheses to explain the provenance of this delightful statuette.

In his *Life* (p. 363) Cellini tells how the Duchess Eleonora was so charmed by the four figures of the gods that she asked her husband to keep them at court, where Cellini had presented them to her, so that she could privately enjoy their beauty. Far from abiding by her wishes, the artist immediately had them attached to the marble base that he had had specially made by Francesco del Tadda. He thus not only deprived his patrons of the satisfaction that they had the right to expect, but also provoked Eleonora's anger. It is thus quite likely that at some later date, once he had finished the relief with the story of the *Rescue of Andromeda*, now also at the Bargello, Cellini felt obliged to gratify his patrons by producing a bronze of the same size and equal beauty. A preparatory pen drawing for the *Rescue of Andromeda* has also come down to us. Now kept at the Louvre, it presents the wistfully veiled female figure among the group of figures on the right of the composition. The pen strokes are regular and assured, and the volumes so clearly defined that they conjure up the varying degrees of relief found in the sculpture itself, even though certain features were changed in the final version. Cellini appears to be perfectly at home in his interpretation of the *Rescue of Andromeda*, and the female nude with the long flowing hair is certainly one of his finest achievements. The work embodies evident references to Michelangelo: for instance, the spirit separating the female figure from the group of bystanders clearly derives from one of the figures of the damned in the Sistine Chapel *Last Judgement*. As for the figure of Perseus hurtling head downward into the scene, it seems to echo the painting of the same subject by Piero di Cosimo, now at the Uffizi, and indeed the angels in Masaccio and Pontormo's *Expulsion from Paradise,* the former at the Church of the Carmine and the latter at the Uffizi. Whatever he may have borrowed, Cellini used it in an entirely original way. His far-reaching cultural background accounts for the rendering of the dragon, which is more Nordic than Italian in inspiration. In fact the long scaly neck is somewhat reminiscent of the armor made by the Negroli brothers in Milan for the kings of France.

At all events, the most significant and anti-classical aspect of the whole creation is the way Cellini deliberately arranged the composition in non-narrative terms, opting instead for a simultaneity of interacting events, rather as he had done in the seal for Ippolito d'Este. This was going against the classical principles of theatrical representation, regardless of the unity of space, time and place that was held to be fundamental to modern portrayals of historical events. The myth that was being enacted before the very eyes of the viewer was like a form of suspended reality for Cellini, a hazy, distant dream-like event with a purpose that eludes that of everyday logic. Thus the appearance of the horsemen in the highest point of the composition is like a sudden flash of a homage to the wild-horse-breakers that feature with entirely different intent in Leonardo's unfinished *Adoration of the Magi*. Though Cellini fails to mention it at all in his autobiography, the composition must have met with the Duke's favor, so it is strange that it did not elicit a further commission for a similar creation for his own private enjoyment.

Granted, it was not the most propitious of moments.

85. Benvenuto Cellini and assistants
Shield for Francesco di Cosimo I de' Medici
cm. 75.5
Dresden, Staatliche Kunstsammlungen

86. Benvenuto Cellini and assistants
Shield, detail of oval with picture of Bianca Cappello
Dresden, Staatliche Kunstsammlungen

72

87. Benvenuto Cellini and assistants
Shield, detail of oval with picture of Francesco I
Dresden, Staatliche Kunstsammlungen

73

*88. Benvenuto Cellini and assistants
Shield, detail of the Story of David
Dresden, Staatliche Kunstsammlungen*

The war with Siena had proved to be graver than expected, and although Cosimo himself controlled all payments for the imperial landsknechts, for his own cavalry led by Giangiacomo Medici di Marignano, and for the supply of arms, ammunition and food-stuffs, very little remained for the purposes of satisfying the pleasures of his court.

By 1556 Cellini was still waiting to be paid the remaining five hundred crowns from the fee of three thousand five hundred settled for the *Perseus*. He was also owed three years of back-payments for his salary as well as part of the Altoviti debt that had been taken over by the Duke. It was not a good year for him. In August he ended up in the Stinche prison for having smashed the goldsmith Giovanni di Lorenzo Papi's head. It was only when the Duke interceded and paid an enormous fine for him that he was released. Nor was this all. On 27 February 1557 he was again accused of sodomy. He admitted his guilt, perhaps to avoid torture, and was sentenced to four years in jail and a further fine of fifty crowns. Deprived of his civil rights, as the law imposed, he was once more helped by Cosimo, who got the Bishop of Pavia to act on his behalf so that the sentence could be changed from prison to mere house arrest.

Cellini was thus able to carry on with the marble *Crucifix* that he had sworn he would make following a vision that he had while he was a prisoner at Castel Sant'Angelo. The Dominican friars of Santa Maria Novella had agreed to locate the work by the artist's tomb, on a pillar between the Gondi Chapel and the adjacent one, in a similar position to that of Brunelleschi's *Crucifix* in the opposite branch of the transept. Moreover, there was also to be a tondo with the Virgin and Child accompanied by a series of figures, including the angel interceding with Saint Peter on the point of turning to Christ. Such were the elements of Cellini's original vision.

The project underwent several changes and was finally abandoned, as Cellini's various wills and codicils reveal. There may in fact have been insurmountable financial problems, since Cellini had officially set up a family by marrying his housekeeper, Piera di Salvatore Parigi, in 1562.

A disagreement with the Dominican friars ensued, since they did not know where to place his sarcophagus. In the end Cellini applied to the Church of the Annunziata, which not only agreed to house his sculpture but also his tomb. This is indeed where he was buried. However, the fact that Bandinelli had man-

aged to have his tomb placed in the Pazzi Chapel, with a *Christ Sustained in Mercy by Nicodemus*, one of his finest works, on the altar, induced Cellini to give up as far as the *Crucifix* was concerned. Instead he decided to make a gift of it to Eleonora of Toledo: "My lady, I have undertaken for my pleasure one of the most laborious works ever produced by anyone: I am doing a figure of the Crucified, in snow-white marble, on a cross in the blackest marble, and it stands as high as a tall living man" (p. 380). Knowing the artist, the Duke would not accept the work as a gift but instead agreed to buy it. When Cellini asked for an exorbitant sum, his patron had the sculpture valued and in the end paid him less than half of the two thousand crowns originally requested. The *Crucifix* was due to be placed in the Grand Duke's private chapel at Palazzo Pitti. However, Cosimo died in 1574, and two years later Francesco I de' Medici had it sent off as a gift to Philip II of Spain. The King was so flattered by this splendid present that he wrote the donor a sincere letter of thanks and had the work placed in the Escorial. It is still there to this day, replete with Cellini's name and the date 1562 inscribed on the cross.

With respect to his other works, the marble Cruci-

fix reveals Cellini's consummate skill in carving. Although he was unaccustomed to working in marble, he proved that he could handle it superbly well. All the technical virtuosity of the high Renaissance continually vying with antiquity is to be found in that languishing figure, captured as he breathes his last.

The way the hair thickens in one place and thins out in another deliberately recalls the smooth delicacy of Greek statuary, especially the *Laocoon*, but also the figures of the dying Galatians, only some of which were known at the time. By the same token, the gentle rendering of surface qualities, the 'skin' of the marble, is also reminiscent of antique sculptures such as the *Hermes* or the *Meleager* at the Vatican Belvedere. These latter had been discovered in 1543 and 1546 respectively, thus allowing Cellini to absorb unwitting reflections of the art of Praxiteles and Skopas.

We know little else for certain about the rest of Cellini's activity, apart from the fact that he unsuccessfully took part in the competition for the *Neptune* in Piazza della Signoria which was eventually won by Bartolomeo Ammannati. Like Giambologna, Vincenzo Danti, Francesco Simon Mosca and Ammannati himself, he had created a model of what he had in mind and set great store on winning. Al-

though he claims that Cosimo was very impressed by his composition, it may in fact have been less beautiful than he himself believed, especially in view of how, according to contemporary sources, Michelangelo declared that the aging sculptor had on that occasion been badly served by his own hands. Despite the negative judgement of his contemporaries, all attempts to identify his composition with extant bronze statuettes such as the one in the Reileigh North Carolina Museum have proved fairly unconvincing.

More recently a chased *morion* and *shield* now kept at the Historisches Museum in Dresden have also been attributed to Cellini. Both the tall crested helmet and the oval shield are ceremonial objects embellished with decorative scenes, along the lines of the *morion* and *shield* in enameled gold made by Pierre Redon for Charles IX of France, now at the Louvre. In Italy and Germany, by contrast, ceremonial shields were usually round and the helmets more compact, in the ancient manner. Apart from being evidently French in influence, however, the two Dresden pieces also reveal stylistic features that were typical of Cellini: the terrible, frozen head of the Medusa in the center of the shield, for instance, or the skillful portrayal of Francesco de' Medici and his lover Bianca Cappello in the two ovals. Moreover, around the stories of *David* and *Judith*, so dear to Florentine erotic iconography, there are also long-necked, narrow-chested Victories that recall the figure of the Land in the *Salt-Cellar* made for François I of Valois, as well as prisoners with

90. Pierre Redon
Gold shield for Charles IX of Valois
cm. 23.9
Paris, Louvre

91. Pierre Redon
Gold morion for Charles IX of Valois
Paris, Louvre

ancient armor. As for the helmet, it features a tondo with the *Conversion of Saint Paul* and another one with a triumph of a figure bearing ceremonial arms. The pointed crown worn by this latter, in keeping with Roman imperial coinage, and the scepter terminating in a lily that he holds in his hand allow us to identify him with Cosimo I. The dog following the sovereign on horseback also calls for a brief comment. It acts as a sort of trademark, like the one the artist could not resist adding to the far right of his relief with the *Rescue of Andromeda*, a griffon that really has nothing to do with the event illustrated. Cellini does not mention his love of animals in his autobiography, yet even the medallion that he used as a casting proof for his *Perseus* features a finely portrayed greyhound. Francesco I de' Medici's equipment must also have included the gunpowder case with *Samson and Delilah* that now belongs to the Royal Armouries at the Tower of London. It appears to have been fashion-

76

ed by another hand, however, since the chiseling is colder and more rigid. It could thus be the work of one of the Poggini brothers, who worked with Cellini for a long time, as documentary evidence reveals. This item also features those little masks that Cellini often mentions in his descriptions of the works that he executed or designed as a goldsmith. They are clearly of Michelangelesque derivation, to the extent that they recall the ones attributed by some scholars to Tribolo in the flooring of the Biblioteca Laurenziana. The center of the composition is taken up by the Medici arms, without the crown or other attributes, which means that the object belonged to a member of the family and not to the Grand Duke himself. These pieces would have been made around 1570, when Francesco de' Medici had been introduced to State government by his father. He could thus have worn his own arms together with those of his wife, Joan of Austria. The fact that the Medici bezants feature here alone can be explained by the particular nature of the object in relation to the commission.

The panoply was never actually listed in the inventories of the armory or the Wardrobe. The reason for this may well be that it was a gift of Bianca Cappello, who at the time was still Francesco's lover. At the premature death of his first wife, Charles V's niece, the two were able to marry and make their love public.

Since it would have been indelicate to exhibit such a masterpiece in the gallery beside the family's other military vestiges, it was soon eliminated by Grand Duke Ferdinando I, who succeeded Francesco in 1587, and sent to the Elector of Saxony in Dresden. First, however, the inscription explaining the history of the objects was removed from the plaque on the *Medusa*'s forehead, where it was all too visible.

It is easy to imagine Cellini acting as an accomplice in the Grand Duke's private life, happy to be *au fait* with so intimate a secret of the young lord. The two of them had immediately taken a great liking to each other, and Cellini, who was very much the sixteenth century courtier, must have been delighted to be accepted among the high and mighty.

The armor is the only example of Cellini's supreme skill in chasing that has come down to us. Unfortunately it eluded Plon, who nevertheless linked Cellini's name to a number of shields and helmets made for the French court that later scholars have traced back to the work of Eliseus Libaerts on designs by Etienne Delaune. We still do not know whether or not Cellini actually executed other pieces of decorated armor, but the documents in his Florentine workshop make frequent reference to supplies of cold steel arms, as well as jewels, ornaments, pins and buckles. Unfortunately the use of precious materials has proved detrimental to the immortality that such masterpieces really deserved.

Bibliography

C. AVERY, *Benvenuto Cellini's Bust of Bindo Altoviti*, in 'Connoisseur', 198, 795, 1978, pp. 62-72.

S. BARGAGLIA, *L'opera completa del Cellini*, Milan 1981.

P. BAROCCHI, ed., *Trattati d'arte del Cinquecento*, Bari, 1960-1962.

A. BERTOLOTTI, *L'Atelier de Benvenuto Cellini*, in 'Gazette des Beaux Arts', 13, 1876, pp. 394-397.

W. BODE, *Italian Bronze Statuettes of the Renaissance*, ed. by J.D. Draper, New York 1980.

B. BOUCHER, *Leone Leoni and Primaticcio's Moulds of Antique Sculpture*, in 'The Burlington Magazine', 123, 1981, pp. 23-26.

P. CALAMANDREI, *Nascita e vicende del "mio bel Cristo"*, in 'Il Ponte', 6, 1950, n. 4 pp. 379-393, n. 5 pp. 487-499.

B. CELLINI, *Autobiography,* trans. by George Bull, Penguin Classics, 1969 (the passages in inverted commas in the text are taken from this edition).

M.G. CIARDI DUPRÈ DAL POGGETTO, *Nuove ipotesi sul Cellini*, in *Essays presented to Myron P. Gilmore*, II, pp. 95-106, Florence 1978.

V.DONATI, *Pietre dure e medaglie del Rinascimento, Giovanni da Castel Bolognese*, Ferrara 1989.

G.G. FERRERO, *Opere di Benvenuto Cellini*, Turin 1972.

J. GELLI, *Tra Benvenuto Cellini e Filippo Negroli*, in 'Rassegna d'arte', 2, 1902, pp. 81-85.

J. HACKENBROCH, *Renaissance Jewellery*, Munich-New York 1979.

J. HAYWARD, *La Giunone in bronzo di Benvenuto Cellini*, in 'Arte Illustrata', 7, 1974, pp. 157-163.

J. HAYWARD, *Virtuoso Goldsmith and the Triumph of Mannerism*, 1540-1620, London 1976.

D. HEIKAMP, *Nuovi documenti celliniani*, in 'Rivista d'arte', 33, 1958, pp. 36-38.

D. HEIKAMP, *Benvenuto Cellini*, Milan 1966.

A. HEISS, *Les Médailleurs de la Renaissance. Florence et les Florentins*, Paris 1891-1892.

G.F. HILL, *Medals of the Renaissance*, revised and enlarged by J.G. Pollard, London 1978.

F. KRIEGBAUM, *Marmi di Benvenuto Cellini ritrovati*, in 'L'Arte' n.s., vol. II, 1940, pp. 3-25.

A.M. MASSINELLI, *Bronzi e anticaglie nella Guardaroba di Cosimo I*, Florence 1991.

B. PAOLOZZI STROZZI, *Monete fiorentine dalla Repubblica ai Medici*, Florence 1984.

A. PARRONCHI, *Il modello "de cera alba" del Cristo celliniano dell'Escuriale*, in 'Studi Urbinati', 41, 1967, pp. 1123-1132.

L. PLANISCIG, *Piccoli bronzi italiani del Rinascimento*, Milan 1930.

E. PLON, *Benvenuto Cellini, orfèvre, medailleur, sculpteur. Recherche sur la vie, son œuvre et sur les pièces qui lui sont attribuées par Eugène Plon*, Paris 1883.

J.G. POLLARD, *Italian High Renaissance Medals*, Florence 1983.

J. POPE HENNESSY, *La scultura italiana. Il Cinquecento e il Barocco*, Milan 1963.

J. POPE HENNESSY, *A Bronze Satyr by Cellini*, in 'The Burlington Magazine', 134, 1982, pp. 406-412.

J. POPE HENNESSY, *Cellini*, Florence 1989.

Sotheby's auction, New York, 10-11/I 1995 (exhibition at Palazzo Doria Pamphjli, Rome 7-8/XI 1994, no. 10).

M. SCALINI, *L'arte italiana del bronzo*, 1000-1700, Busto Arsizio 1988.

M. SCALINI, *Capolavori a sbalzo per i Medici: Cellini e altri maestri*, Florence 1992.

G. SOMIGLI, *Notizie storiche sulla fusione del Perseo con alcuni documenti inediti di Benvenuto Cellini*, Milan 1958.

M. SPALLANZANI, *Saluki alla corte dei Medici nei secoli VV-XVI*, in 'Mitteilungen des Kunsthistorischen Institutes in Florenz', XXII, 3, pp. 360-366.

I.B. SUPINO, *L'arte di Benvenuto Cellini*, Florence 1901.

D. TRENTO, *Benvenuto Cellini opere non esposte e documenti notarili*, Florence 1984.

W.R. VALENTINER, *Cellini's Neptune Model*, in 'Bulletin of the North Carolina Museum of Art', I, 3, 1957, pp. 5-10.

C. VERMUELE, W. CAHN, R. HADLEY, *Sculpture in the Isabella Stewart Gardner Museum*, Boston 1977.

M. WINNER, *Federskizzen von Benvenuto Cellini*, in 'Zeitschrift für Kunstgeschichte', 31, 1968, pp. 293-304.

Index of Illustrations

Other Artists

93. Benvenuto Cellini
Apollo, study for the Accademia del Disegno seal; cm. 28,4x20
Stanley Moss Collection, Riverdale on Hudson, New York